THE ERA OF THE FRENCH CALOTYPE

Janet E. Buerger International Museum of Photography at George Eastman House

This exhibition was supported in part by
funds from the National Endowment for the Arts,
a Federal Agency, and the New York State Council
on the Arts.

Additional funds for the Catalogue were provided
by the Gannett Foundation.

Design: Robert Meyer Design, Inc.
Typography: Rochester Mono/Headliners
Printing: Ayer & Streb
Binding: Riverside Book Bindery

Cover: Henri LeSecq, (Rustic scene), ca. 1852.
 Cyanotype from paper negative.

The Era of the French Calotype

Introduction

I. The Sources of Early French Photography at Eastman House

The International Museum of Photography at George Eastman House has one of the largest collections of early French photography in the world. This short catalogue and the exhibit which it celebrates are steps toward a larger effort to fully record and publish the Museum's holdings in this area.

The sources of the material begin with Gabriel Cromer, a French lawyer turned photographer, who devoted the better part of his life to amassing the most significant private collection of photographic history before World War II. He fought vigorously but vainly to establish a Museum of Photography before others recognized the worth of such a project, and would certainly be happy that his treasures are now available at the Bibliothèque Nationale and Eastman House. The major part of the collection was purchased by the Eastman Kodak Company from Cromer's widow in 1939, through the farsighted efforts of Dr. Walter Clark and Dr. Kenneth Mees (and it was shipped out on the last boat to leave France before the war ensued). The company generously transferred the collection to Eastman House when the Museum was chartered in 1947.

Cromer—from sources which are not always clear—managed to absorb not only prints but an enormous library of books, manuals and periodical literature relating to photography. The collection includes a number of Henri LeSecq's own paper negatives; Gustave LeGray's own annotated copy of his 1852 manual, *Photographie, traité nouveau des procédés et manipulations;* an 1869 edition and one of 50 copies printed of the 1870 edition (all with different tipped-in photographs for illustrations) of Blanquart-Evrard's *La Photographie, ses origines, ses progrès, ses transformations;* Marville's reproduction of a painting of Homer, autographed by the artist Ingres to his friend Sturler; a number of photographs originally from the library of the Empress Eugénie and Napoleon III at Compiègne; a photographic album about Victor Hugo assembled by himself, Charles Hugo and Auguste Vacquerie; and the personal album of Eugène Durieu, president of the administrative committee of the French Society of Photography and collaborator with the painter Delacroix on the latter's private album of photographic *académies.* These and other riches make a comprehensive history of photography unimaginable without generous reference to the Cromer collection.

In 1950 the Museum made another important acquisition, through Kodak-Pathé and the French Society of Photography, from Henri Fontan *(Médaille Militaire, Croix du Combattant Voluntaire, Pensionné de Guerre)* of Douai. Fontan owned a sizable collection of photographica including what were "probably the work books of Blanquart-Evrard": hundreds of stunning calotypes from ca. 1850-55 of the area and towns of Normandy. Impressed by "the deliverance of France, made possible by the American Nation and the genius of General Eisenhower", he arranged to offer the collection to the United States through the then new museum of photography in Rochester. Fontan also sent a letter that Delacroix in 1853 had written in appreciation of photography, probably to his friend Desavary in Arras, and the original edition of the rare Blanquart-Evrard book mentioned above, however with another entirely different set of illustrations.

French collectors alone were not responsible for all of the material presented here. In 1950, the great Chicago photo enthusiast Alden Scott Boyer handed over his huge American collection of photographica to Eastman House, including a number of important French pieces such as the plates from various Blanquart-Evrard publications and Maxime DuCamp's 128 plate *Egypte, Nubie, Palestine et Syrie* (1852). In 1977 the 3M Company donated the entire holdings of the American Museum of Photography, assembled earlier this century by the Philadelphian Louis Walton Sipley. From these has been drawn the fine LeGray portrait of Napoleon III.

An active acquisition policy over the years has guaranteed added treasures: over 100 LeSecq architectural pictures, including the Chartres Cathedral portfolio; a rare 1862 album by Victor Prevost of Central Park in New York; and, most recently, Eugène Piot's picture of the Erectheum in Athens.

II. The Strengths of the Collection

The Eastman House holdings are diversity itself. The majority of the pictures here could be classified as art, but most of them also represent a period of interconnecting disciplines, and an era during which photography achieved the perfection necessary to serve as a tool for every field. It was an era susceptible to the using of that tool, and an era in which men of every walk of life met enthusiastically over the boards of photographic societies.

The collection is strong enough to indicate these connections. It includes items from important documentary projects that were commissioned by the government from artists who either temporarily (LeSecq, LeGray) or permanently (Baldus) switched to the photographic medium as an occupation. It includes the illustrations from early publishing ventures (Blanquart-Evrard), and of photography as an archeological tool (Salzmann) or tool for the artist (Durieu, Braquehais). And it includes personal albums for the private citizen (the Vallou de Villeneuve album, the Victor Hugo album).

The collection holds enough material by some of the photographers to judge their consistency or diversity, their method of operation, or their development through various processes (Baldus, Bisson frères, Braun, DuCamp, Durieu, LeGray, LeSecq, the Normandy *Cahier* artist, Prevost, and Vallou de Villeneuve, for example.) Finally, it is possible to arrange the material variously by subject matter, so that the same photographers speak different "sentences" depending on the context in which they are placed. This is the way—the exciting and confusing way—that photography was seen in the 1850s.

III. The French Calotype: A Paper Photograph from a Paper Negative

When photography was introduced to the public in 1839 it was presented in several forms. The first practical process was L. J. M. Daguerre's unique no-negative image on a silvered copper plate, the daguerreotype. At the same time the Englishman William Henry Fox-Talbot announced a paper-negative/ paper-positive photograph, the calotype (from the Greek *kalos*, meaning beautiful). A third process, though little used, was invented by Hippolyte Bayard: a unique positive image on paper.

The calotype had wonderful advantages over the daguerreotype: it had none of the reflection problems associated with the daguerreotype; its negative/positive technique allowed for multiple prints of the same picture; it was cheaper; it was lighter, and so was recommended for "views" or other pictures taken on travels or away from the studio. And paper photographs could be tipped into an album or a publication, a practical application with meaning for the future.

In the early years of photography the daguerreotype was faster (requiring less exposure time), sharper, with a greater and more subtly gradated tonal range, and more successful at registering aerial perspective. Photographers favored it throughout the 1840s. The public loved its dazzling, jewel-like quality. In 1851 Alexis Gaudin claimed that 19 out of 20 practitioners still preferred it to paper photography. Even so, there were several early masters of the calotype, like Bayard (1—4) and Pec (5—6)*. By 1850 Vallou de Villeneuve was producing beautiful portraits (19), Maxime Du Camp was already in Egypt with Gustave Flaubert, shooting views destined to be printed by Blanquart-Evrard's "permanent" method and published in *Egypte, Nubie, Palestine et Syrie* (191—197), Count Flacheron was active in Rome (189) and Paul Marès may already have been in Algeria (205).

In the late 1840s and early 1850s a number of new innovations drew increased attention to paper photography. In 1847 Nièpce de St. Victor invented the albumen negative on glass, with a capacity to reproduce the detail so admired in the daguerreotype. By 1850 Louis Desiré Blanquart-Evrard introduced albumen paper for positive prints (with an emulsion made of egg whites), producing a wider tonal range than salt prints. And in the same year LeGray published his waxed paper negative technique, which not only reduced the grain of the paper negative on the positive print, resulting in greater smoothness and sharpness, but, most importantly, offered a negative sensitized and dried far in advance of shooting the picture—a boon especially for the traveller, who had been carrying his darkroom around with him. The new advantages of paper photography almost overnight provided competition for the daguerreotype.

Finally by 1851, Frederick Scott Archer had created a workable collodion negative on glass process—the collodion base had also been discovered by LeGray, who never-

theless continued perfecting his paper negative process. The collodion negative was capable of the sharp detail and tonal range of the daguerreotype in addition to the reproducibility of a negative/positive process. Easier and faster than other negative processes, it would by about 1863 take over the field to the near exclusion of all other procedures.

The period of the 1850s was not limited to these few processes, however. It was a time of rich experimentation, introducing entirely new procedures, and improving or presenting variations on old ones. Nearly half the photographic literature of the 1850s was devoted to these discoveries. For each photographer who worked primarily with one process (LeSecq with paper negatives), there were dozens who worked with more than one (LeGray with daguerreotypes, paper negatives and wet collodion negatives; Bisson frères with daguerreotypes, paper negatives and glass negatives; Bayard with his own direct positive paper process, daguerreotypes, paper negatives and wet collodion negatives; Baldus with waxed paper negatives and collodion negatives; Durieu with daguerreotypes, paper negatives and glass negatives, etc.). Almost all of them worked with varying positive-print methods (LeSecq with salt prints, cyanotypes [blueprints] and greasy ink gravures; LeGray with salt prints, albumen prints and variations of toning; Baldus with salt prints or treated salt prints, albumen prints and gravure). To reveal this complexity, so characteristic of the period, a variety of types of pictures are included here. The focus of the show nevertheless remains on the calotypist (the earliest breed of paper photographer), on what he achieved and on how he fit into the development of photography in its early stages in France.

The calotype—strictly speaking a salted paper print *from a paper negative*—was the darling process of the 1850s. LeGray in his first manuals on photography claims it as "a scrupulous reproduction of nature" and a tool for the artist.

> *The future success of photography rests entirely on the paper process . . . (The amateur) will obtain upon paper as much finish and more artistic effect than upon glass. The pictures upon the latter are certainly very fine but artistically hard . . .[1]*

> *The glass negative, to be sure, is sharper, but I believe that it is a false route, and that the goal is to arrive at the same results with the paper negative . . . Glass is difficult to prepare, fragile, encumbering on a journey, and slower to receive the luminous image.[2]*

Sir John Hershel claimed that compared to the daguerreotype, Talbot's process produced only "fog." But to much of the artist and *amateur* contingency within the photographic community (LeSecq, Negre, Baldus, Vallou de Villeneuve, Cuvelier, Caneva, Flacheron, etc.) and to some of the most prominent photo critics of the time (Francis Wey, Ferdinand de Lasteyrie, Ernest Lacan and Henri de Lacretelle) the *"brouillards"* of the paper-negative photograph had distinct and unique potential as art. The process allowed for a submission of detail to masses of highlight and shadow, creating a greater degree of *effet* (the total effect of the work).

*Numbers in parentheses refer to exhibition checklist which begins on page 5.

Two styles are apparent in the prints. Ferdinand de Lasteyrie noted at the end of the 1850s:

Photography has its classicists and its romanticists; the former pursue reality in fine detail and clearness of line, the latter love the nuances and games of light and avoid the drawing that would call on minutia in favor of the nature of broader effects.[3]

On the one hand there was a tendency to use the inherent grainy quality of the paper negative to produce romantic compositions relying heavily on the effect of chiaroscuro, variable focus or blurred movement. Of this style Henri LeSecq was an acknowledged master (52, 54—61). His "Rustic Scene" (52) is a *chef d'oeuvre* of the "calotype aesthetic" and Henri de Lacretelle mentions others of his "landscapes that dream in silence" and "studies of sand-pits and ravines" that, now lost, were undoubtedly works of the same general type. In his *fantaisie* still lifes (54—58) he invites the viewer to participate by offering a glass of spirits (54, the presumed frontispiece to an album series), and carefully controls the visual experience through expert focusing and mastery of light. In his boat scenes (60—61) one gets the feeling that the subject is light itself, the boats only an excuse to play the game. Modern painting and contemporary photography owe much to this type of imagery.

On the other hand, photography—and calotypy—aimed simultaneously at another goal: a sharp-focus, detailed document. Louis de Cormenin, to whom DuCamp dedicated his *Egypte, Nubie, Palestine et Syrie* (191—197), remarked of the plates:

Where the pen is impotent to know them in the truth of all their aspects, these monuments and landscapes, where the pencil is capricious and loses its way, altering the purity of the subject, photography is unyielding . . . There, not fantasy or trickery, but nude reality.[4]

Indeed, DuCamp's views were among the earliest to successfully incorporate hard-edge detail. Nor was this an easy matter in 1850. DuCamp retrospectively apologized:

If some day my soul is condemned to eternal damnation, it will be in punishment for all the rage, the fury, the vexation of all kinds caused me by my photography, an art which at that time was far from being as easy and expeditious as it is today.[5]

Flaubert, who witnessed DuCamp's efforts in Egypt, thought he was insane.

As LeGray's comments (above) tell us, many thought that paper negative photography was more artistic than glass negative photography; but the achievement of sharpness—as promised in the glass negative—was a constant goal of the calotypist as well. LeGray felt that sharpness could be accomplished with the paper negative; he and others proved that this was partly true. The document (31—32, 40—49) required detail. Artist-photographers, too, took calotypes and glass negative pictures of the same subjects and hung them side by side at the French Society of Photography exhibitions. History tells us that the calotype suffered from these comparisons, and that it was only a step in a longer progression toward the perfect process.

This exhibition presents three things, not just one. First, it offers numerous prints created with a "calotype aesthetic"—a short-lived aesthetic that produced some of the finest and most alluring images in the history of pictorial art. Second, it offers a number of their earliest "competing" glass negative relatives. Third, it offers a privileged view of the passage of one of the most significant media of all time from its infancy to its maturity, through the calotype stage to the sharply detailed imagery that has forever since been judged the inherent style of the photographic print.

Note: The designation "calotype" is given only to those prints that are certainly salted paper positives made from paper negatives. All positives from paper negatives might be loosely termed calotypes, but the word is not applied here in those instances. The word calotype, which was an English term, was almost never used in France, partly to avoid Talbot's patent restrictions and partly because the many variations invented in France fit only seldom into Talbot's original mold.

All titles in English are by the author.

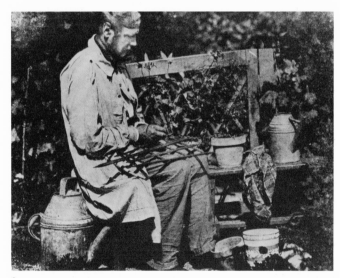

3
HIPPOLYTE BAYARD
Bayard jardinier
1842-1852
Modern print (1965) from a paper
 negative in the collection of the
 French Society of Photography
17.2 x 22.3 cm
81:0962:8
Museum purchase

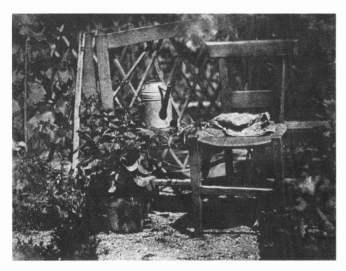

1 (not illustrated)
(?HIPPOLYTE BAYARD)
(Statuette of woman in classical
 costume, outdoors)
ca. 1840
Salted paper print
19.0 x 12.5 cm
81:2403:1
Provenance: Gabriel Cromer
 Collection; Degeorges, sculptor
 and engraver in medals

2 (not illustrated)
(?HIPPOLYTE BAYARD)
(Statuette of woman in classical
 costume, outdoors)
ca. 1840
Salted paper print hand-touched
 in pencil and wash
17.7 x 12.2 cm
81:2403:2
Provenance: Gabriel Cromer
 Collection; Degeorges, sculptor
 and engraver in medals

4
HIPPOLYTE BAYARD
Chaise dans un jardin
1842-1852
Modern print (1965) from a paper
 negative in the collection of the
 French Society of Photography
17.0 x 22.8 cm
81:0962:4
Museum purchase

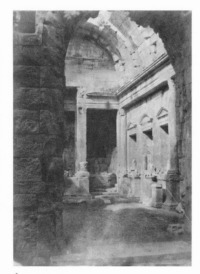

5
P.E.C. (EMILE PEC)
Nîmes (Roman Nymphaeum)
1846
Calotype
29.0 x 21.7 cm
80:0535:2
Provenance: A. E. Marshall
 Collection
Museum purchase

6
(EMILE PEC)
(Nîmes Roman Nymphaeum,
 detail, doorway)
ca. 1845-1850
Calotype
30.3 x 22.5 cm
82:1648:1
Provenance: A. E. Marshall
 Collection
Museum purchase

THE CATALOGUE

I. The Times and the Context

Though photography itself was not an invention of the Second Empire (1852-1870), paper photography first flourished under the Emperor Napoleon III. Napoleon and his various ministries, indeed, were active patrons of the new medium (see below under "Patronage"). The times were marked by industrial advance, the rise of Naturalism, a fervor for documentation, and a concern both romantic and scientific for world travel and for Medieval architecture and its preservation. It was a time when art, physics and chemistry witnessed great surges of activity, and a time that included the rise of photography as a new visual medium.

In photography, this was not solely—or even mainly—a time of calotypy, and few of the photographs represented in this section are calotypes. It was a time that witnessed Disderi's *carte-de-visite* vogue, and more generally, a period of what Jean Keim, the great photo historian, called "portrait mania" (Nadar, Adam-Salomon, Carjat, Pierre Petit). But most of the portraitists chose to work with wet collodion glass negatives.

This was surely a world worthy of portraiture. Literary, scientific, artistic and musical figures of the time form a who's who of modern cultural history. The avant-garde is superbly represented in Nadar's *Panthéon* (10). In order to help prepare this huge lithograph, Nadar the caricaturist resorted to photography, and he executed some of the finest portrait studies of the era. His prestigious assembly conveniently presents us with the ambience of the early photographers and with many of the figures that history has judged the essence of the period: George Sand, Balzac, Baudelaire, Alexandre Dumas, Gustave Doré, Berlioz, Rossini, Chamfleury. It even includes a few photographers: Nadar himself, DuCamp, Charles Hugo, Auguste Vacquerie, and the photo critic Francis Wey.

During this period the visual arts were undergoing tremendous turmoil. A new art based on Realism and *plein-air* painting was emerging and it played a symbiotic role with photography. Courbet (13),championed by Champfleury, was the acknowledged leader of Realist painting and used photographs as inspiration for some of his compositions. The whole question of realism was understandably linked with photography. Corot (12) was associated with the modern artists' group of Arras (which included Dutilleux, Desavary, and Eugène and Adalbert Cuvelier, 138, 139) and with the related school of Barbizon (Millet, Théodore Rousseau, Diaz, 11). Desavary and Eugène Cuvelier would constantly supply painters with photographic *études d'après nature* and would do a great deal to encourage artists to use the new medium as sketch-matter for their compositions. Eventually the Arras group would develop the printing technique based on the *cliché-verre,* a glass negative made by an artist's drawing rather than by the sun and nature. But the main drive behind both the Arras and Barbizon groups was their interest in creating landscapes direct from the motif, out-of-doors. Their paintings, therefore, influenced and were influenced

by the new breed of artist: the photographer. Artist and photographer frequently shared the same working and vacation spots and, thus, a similar imagery as well.

In 1855 the Exposition Universelle featured retrospectives of the work of the two giants of the grand manner: the neoclassical painter Ingres (21, 22) and the Romanticist Delacroix (20). These more established styles are also reflected in early photography and they certainly informed the "artistic" studies of Eugène Durieu (26). Delacroix and Durieu collaborated on a smaller album of photographic *académies* (artist's studies of male and female models) which Delacroix kept for continuous reference, and which is now in the Bibliothèque Nationale. The great demand for such studies enticed other photographers to do them too, including Braquehais (27) and Vallou de Villeneuve (here represented by his portraiture, 19). Gustave LeGray commercially offered studies of figures, trees and drapery (probably like 22-23) to artists. And in 1853, painter Louis d'Olivier established a *Société photographique* (with the history painter Léon Cogniet at its head) specifically for the purpose of creating photographic *académies.*

Many painters, both established (Delacroix and Léon Cogniet) and more avant garde (Paul Huet, allied with the pre-Impressionists) were among the earliest members of the *Société héliographique* (formed in 1851) or attendants of its meetings. Paul Perier, the vice president of the French Society of Photography (established in 1854) appears to have been the great supporter of the Barbizon painters and an influential art critic in later years. So photography, while capable of presenting creative images for its own sake, was intricately associated with the traditional arts as well.

Reproduction played a more important role in these years than we generally recognize today. The minute after photography was announced in 1839, the critic Jules Janin remarked with excitement:

> *The daguerreotype is destined to popularize among us, and cheaply, the most beautiful works of art of which we have now only costly and inaccurate reproductions. Before long one will send his child to the museum and tell him: in three hours you must bring me back a painting by Murillo or Raphael . . .*[6]

The reproduction of works of art, of which Fierlants (18, 19) was a master, was a specialty of many photographers, and was accepted as a tool by painters. The artist Ingres evidently gave his friend Sturler as a souvenir Marville's reproduction of a painting of Homer (17), and the artist Bouguereau exhibited photos of some of his paintings at the Salon of 1859 because the paintings themselves were not available. Other artists sent photos of their Salon work to influential critics, hoping to draw their attention. Richebourg photographed the paintings in the Salon of 1857; Bingham assembled albums of prize pictures from the exhibition of 1859; Bisson frères published a book on Rembrandt; and Blanquart-Evrard reproduced Poussin.

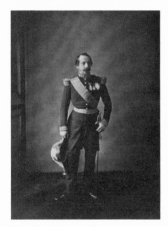

11 (not illustrated)
(NADAR)
Narcisse Diaz de la Peña, painter
ca. 1865?
Albumen print from glass negative
20.5 x 16.4 cm
78:0643:5
Provenance: Gabriel Cromer
 Collection

7
MAYER FRERES AND PIERSON
Napoleon III
ca. 1860
Albumen print from glass
 negative?
32.5 x 24.2 cm
81:1638:1
Provenance: Gabriel Cromer
 Collection

8
ADOLPHE-EUGENE DISDERI
Napoleon III
ca. 1855-1860
Albumen print from glass
 negative?
Carte-de-visite
81:1205:1
Provenance: Gabriel Cromer
 Collection

9
GUSTAVE LEGRAY
Napoleon III
ca. 1855
Salted paper print
20.2 x 14.5 cm
79:3011:1
Provenance: 3M/Sipley Collection;
 former American Museum of
 Photography

12 (not illustrated)
CHARLES DESAVARY
Jean-Baptiste Camille Corot,
 painter
1873
Albumen print from glass negative
13.5 x 9.9 cm
81:2289:1

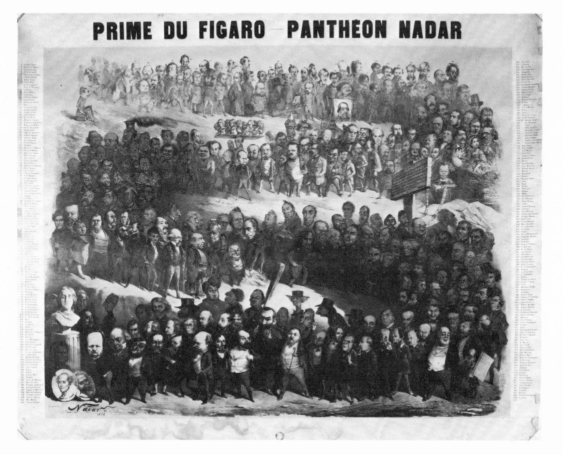

10
NADAR
Panthéon Nadar (Prime du *Figaro*)
1854
Lithograph (Lemercier)
72.0 x 94.5 cm
81:0023:1

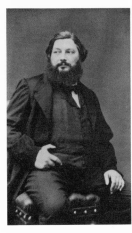

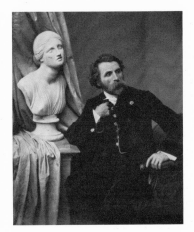

13
PIERRE PETIT
Gustave Courbet, painter
ca. 1860
Albumen print from glass
 negative
Carte-de-visite
69:0183:146

14
ANTOINE SAMUEL
 ADAM-SALOMON, sculptor
 and photographer
Self-portrait
ca. 1860
Albumen print from glass
 negative?
23.3 x 19.5 cm
82:1727:1
Provenance: Gabriel Cromer
 Collection; family of
 Adam-Salomon

15
UNIDENTIFIED
PHOTOGRAPHER
(Four men drinking wine)
ca. 1845-1850
Salted paper print
(oval) 13.6 x 10.6 cm
82:1644:2

16
ABEL NIEPCE DE
 SAINT-VICTOR
(Two men)
ca. 1845-1850
Calotype (reproduction of a
 daguerreotype)
11.3 x 8.5 cm
81:2919:1
Provenance: Gabriel Cromer
 Collection

17 (not illustrated)
ADOLPHE-EUGENE DISDERI
Giuseppi Verdi, composer
ca. 1859-1865
Albumen print from glass negative
Carte-de-visite
69:0102:1
Provenance: Gabriel Cromer
 Collection

18 (not illustrated)
MAYER FRERES AND PIERSON
Rachel, actress
ca. 1855-1860
Photogravure by A. Riffaut
30.5 x 23.2 cm
80:0463:1

19a
JULIEN VALLOU DE
 VILLENEUVE
Mlle Madne. Brohan, Rôle de
 Mariane, dans *Les Caprices de
 Mariane,* from an album owned
 by the actor M. Delaunay
ca. 1851
Calotype
15.7 x 12.3 cm
76:0103:9
Provenance: Gabriel Cromer
 Collection

19b
JULIEN VALLOU DE
 VILLENEUVE
Mr. Geffroy, from an album
 owned by the actor
 M. Delaunay
ca. 1850
Calotype
16.5 x 12.3 cm
76:0103:26
Provenance: Gabriel Cromer
 Collection

19c
JULIEN VALLOU DE
 VILLENEUVE
Mr. Leroux, Rôle d'Acaste, dans
 Le Misanthrope, from an album
 owned by the actor
 M. Delaunay
ca. 1850
Calotype
16.3 x 12.5 cm
76:0103:32
Provenance: Gabriel Cromer
 Collection

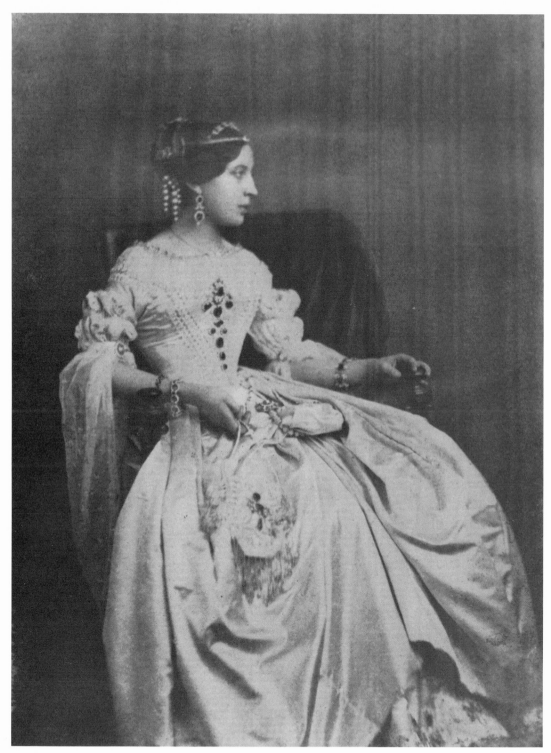

19
JULIEN VALLOU DE
 VILLENEUVE
Mlle Savard, Rôle de l'Infante,
 dans *Les Contes de la Reine de*
 Navarre, from an album owned
 by the actor M. Delaunay
ca. 1850
Calotype
16.2 x 12.1 cm
76:0103:14
Provenance: Gabriel Cromer
 Collection

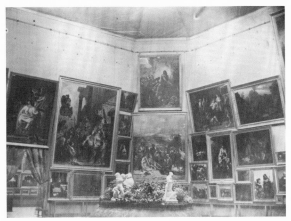

20
UNIDENTIFIED
 PHOTOGRAPHER
(Room with Delacroix paintings),
 from the album *Exposition
 Universelle des Beaux-Arts, 1855*
1855
Albumen print
26.1 x 35.1 cm
79:0020:13
Provenance: Gabriel Cromer
 Collection

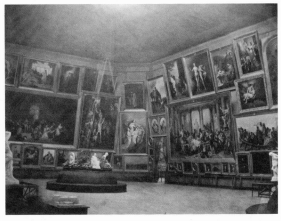

22a
UNIDENTIFIED
 PHOTOGRAPHER
(Room with Couture's "Romans of
 the Decadence"), from the
 album *Exposition Universelle des
 Beaux-Arts, 1855*
1855
Albumen print
26.2 x 35.1 cm
79:0020:9
Provenance: Gabriel Cromer
 Collection

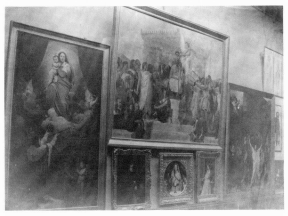

22
UNIDENTIFIED
 PHOTOGRAPHER
(Room with Ingres paintings), from
 the album *Exposition Universelle
 des Beaux-Arts, 1855*
1855
Albumen print
26 x 35.2 cm
79:0020:10
Provenance: Gabriel Cromer
 Collection

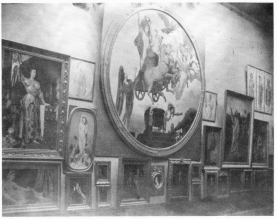

21
UNIDENTIFIED
 PHOTOGRAPHER
(Room with Ingres paintings), from
 the album *Exposition Universelle
 des Beaux-Arts, 1855*
1855
Albumen print
25.9 x 35.1 cm
79:0020:11
Provenance: Gabriel Cromer
 Collection

26
(EUGENE DURIEU)
(Study of a woman in costume),
 from the personal album of
 Eugène Durieu
ca. 1855
Calotype
12.6 x 16.4 cm
79:0079:5
Provenance: Gabriel Cromer
 Collection

23 *(not illustrated)*
CHARLES MARVILLE
Reproduction of a painting of
 "Homer", autographed "à son
 ami Sturler, Ingres"
1862 or after
Salted paper print
21.2 x 18.0 cm
81:1531:2
Provenance: Gabriel Cromer
 Collection

24 *(not illustrated)*
FIERLANTS
Reproduction of Hemling's (sic),
 "Donateurs" (detail of "The
 Baptism of Christ")
ca. 1859
Treated albumen print?
51.0 x 37.3 cm (life size)
81:3092:11

25 *(not illustrated)*
(FIERLANTS)
Reproduction of Memling's
 "Mariage mystique de saint
 Catherine", Hôpital St. Jean à
 Bruges
ca. 1859
Treated albumen prints (5 pieces)
(together) 49.8 x 148.3 cm
81:3109:1

26a
(EUGENE DURIEU)
(Study of two women in costume),
 from the personal album of
 Eugène Durieu
ca. 1855
Calotype
(oval) 12.6 x 16.5 cm
79:0079:54
Provenance: Gabriel Cromer
 Collection

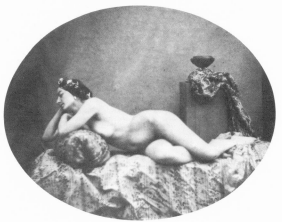

26b
(EUGENE DURIEU)
(Study of a nude woman), from
 the personal album of Eugène
 Durieu
ca. 1855
Calotype
(oval) 12.0 x 16.3 cm
79:0079:70
Provenance: Gabriel Cromer
 Collection

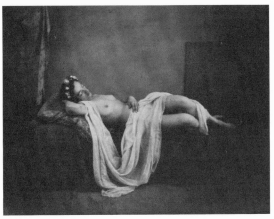

26c
(EUGENE DURIEU)
(Study of a nude woman with
 drape), from the personal album
 of Eugène Durieu
ca. 1855
Calotype
14.7 x 19.3 cm
79:0079:94
Provenance: Gabriel Cromer
 Collection

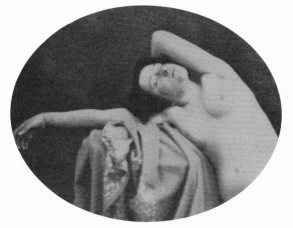

26d
(EUGENE DURIEU)
(Study of a nude woman, waist
 up), from the personal album of
 Eugène Durieu
ca. 1855
Calotype
(oval) 7.0 x 9.0 cm
79:0079:98
Provenance: Gabriel Cromer
 Collection

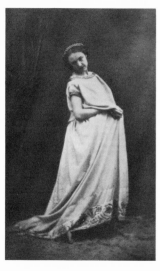 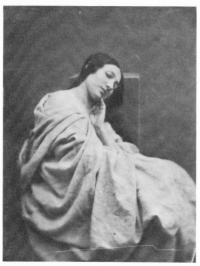 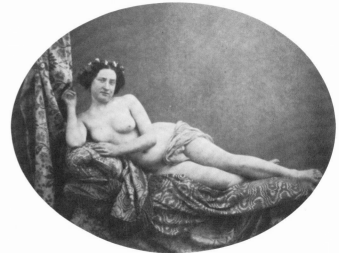

26e
(EUGENE DURIEU)
(Study of a woman in costume),
 from the personal album of
 Eugène Durieu
ca. 1855
Albumen print?
17.0 x 10.5 cm
79:0079:24
Provenance: Gabriel Cromer
 Collection

26f
(EUGENE DURIEU)
(Study of a woman in drapery),
 from the personal album of
 Eugène Durieu
ca. 1855
Waxed salted paper print?
13.0 x 10.0 cm
79:0079:53
Provenance: Gabriel Cromer
 Collection

26g
(EUGENE DURIEU)
(Study of a nude woman), from
 the personal album of Eugène
 Durieu
ca. 1855
Calotype
(oval) 12.7 x 16.4 cm
79:0079:42
Provenance: Gabriel Cromer
 Collection

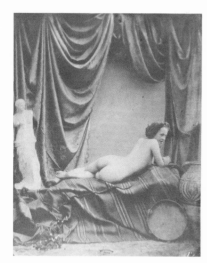 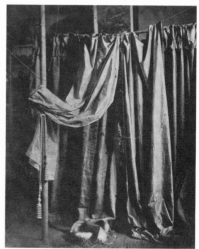

27
BRAQUEHAIS
(Académie with Venus de Milo)
ca. 1855
Albumen print
25.4 x 20.1 cm
80:0205:1
Provenance: Gabriel Cromer
 Collection

28
UNIDENTIFIED
 PHOTOGRAPHER
(Study of drapery)
ca. 1855-1860
Albumen print
20.6 x 17.7 cm
80:0061:2

29
UNIDENTIFIED
 PHOTOGRAPHER
(Study of drapery)
ca. 1855-1860
Albumen print
20.8 x 16.5 cm
80:0061:1

II. The Masters: Art and Documentation

Of the more than forty-seven photographers presented here, many are "masters." Gustave LeGray (30-39), Henri LeSecq (40-61) and Edouard Baldus (62-78) are among the chief of these, and each represents important and different approaches to the calotype.

LeSecq is the classic calotypist. He never became a professional photographer, but rather was typical of the artist and/or affluent amateur who adopted the new medium as a mode of creative expression or as a pastime. It appears that he mastered the technique with all its unique qualities, found that no other photographic process could accommodate his particular artistic needs, and abandoned photography when new processes took over. There is ample evidence to indicate that he was only one of many calotype *amateurs* who never continued in other photographic media.

Gustave LeGray, who had become a professional photographer by 1850, worked with all available processes, including daguerreotypy. Initially he favored the calotype, as we have seen, but he succumbed to the glass negative for much of his later work, including the seascapes. He used focus, composition and general technical control in a highly artistic way—a carry-over from the calotype aesthetic—and he also eventually abandoned photography. According to Nadar, he suffered from the greater success of commercial portrait photographers, but it seems more likely that he too may have practiced a type of artistic imagery that was in style in Paris only in the 1850s. Before he disappeared, he taught many photographers how to calotype including LeSecq, Mestral, DuCamp and Nadar's brother, Adrien Tournachon.

Finally, Baldus, a thoroughly successful commercial photographer, represents a type who adapted not only to the calotype but to the forward-looking glass negative as well. Though when he wanted to (73, 74), he was able to use his paper negatives to achieve that special romantic grainy quality epitomized in LeSecq (52, 54-58), he, like LeGray, found ways to get the glass negative to achieve a similar artistic effect (168). More important, he retained this effect in his calotypes without forfeiting detail (75, 169). For this the critics praised him highly. He did not abandon the process, returning to it in force in the later years of the calotype period and exhibiting only paper-negative pictures in the French Society of Photography exposition of 1861. Baldus was willing to accept the innate photographic quality of accuracy without giving up "art." His superb sharp-focus wet-collodion negative series on the Louvre (65-68) utilized one of several later processes with which he would involve himself. He even developed a photogravure procedure, which he first exhibited in 1869 (77, 78).

LeSecq, LeGray and Baldus were all painters when photography was invented, and other photographers represented here were painters or sculptors as well: Adam-Salomon (14), Vallou de Villeneuve (19), Nègre (79-81), Nadar (4), Salzmann (199-203), Prevost (151-152, 209-18), Flacheron (189) and Caneva (187-188). LeSecq, LeGray and Nègre all studied at the Ecole des Beaux-Arts in the large atelier of the painter Paul Delaroche, from the beginning a supporter of photography. This was quite natural, since the medium was simply a new pictorial mode. All the best photographers, however, did not necessarily begin as artists. Adalbert Cuvelier was an oil manufacturer; Bayard a public servant. Nor were all the artist-photographers limited to creating "art" with their cameras. It is true that LeSecq's *"fantaisie"* still lifes (54-58, and also 59) came directly from a long-standing tradition in painting—particularly inspired from the early Dutch masters—and that LeGray's seascapes (33-39) are purely artistic, but both photographers participated enthusiastically in the strictly documentary projects at hand. Their aim in these projects was straightforward: to reproduce the subject. The calotype's *"brouillards"* had no place in these efforts, and the photographers, knowingly, adjusted for detail.

LeGray, LeSecq and Baldus were three of five (with Mestral and Bayard) whom the Comité des Monuments Historiques hired to document various important buildings in France. This was the well known *"mission héliographique"* of 1851 (30-32, 40-45, 53, perhaps 62-64, which were printed later). LeSecq received another commission in 1852 to document sculptural monuments, a project which seems to have spawned the Chartres Cathedral portfolio (46-49) and to have caused him to return to many of the sites he visited in 1851. The 1851 commission was important because it was the first major recognition of photography as a tool for architectural documentation, and because it recorded numbers of decaying edifices before the massive nineteenth century restorations they subsequently endured. Many negatives from the project are still preserved today in the archives of the Commission in Paris. Vintage prints, however, are rare.

Bayard covered Normandy; LeSecq went to Champagne, Alsace-Lorraine and Picardie; Baldus travelled through Bourgogne, following the Rhône to Provence; LeGray and Mestral photographed the Loire Valley and its *châteaux* on their way to Haut-Poitou and Southwest France.

Among the many thrills of cataloging the Eastman House prints was the discovery of three previously unidentified views belonging to the LeGray mission (30-32). The Chauvigny and Saint-Savin pictures are among the extremely rare extant prints done by LeGray himself. They have the rich gold toning that he introduced for

paper photography in 1847 and that was admired so by contemporary critics.

LeSecq's commission included some of the most famous Gothic cathedrals: Amiens, Reims and Strasbourg. His views sent the critics into raptures. Henri de Lacretelle exclaimed:

> He has reconstructed, stone by stone, the cathedrals of Strasbourg and Reims in more than a hundred different prints. We've climbed, thanks to him, to all the towers, we've suspended ourselves from all the friezes, all the cornices. That which we would never have seen with our eyes, he has seen for us... The cathedral is entirely reconstructed, course by course with the effects of the sun, the shade and the rain. M. LeSecq has also made his monument.[7]

These and the Chartres pictures, which de Lacretelle called "reproduction perfected", were loved for their accuracy and intimacy, while the eerie "Rustic scene" and sophisticated still lifes, so admired today, were hardly mentioned in the literature.

Bayard's commission seems to be all but lost; no negatives have been located in the Commission archives. Luckily, the "Blanquart-Evrard *Cahiers*" (work books), discussed below, include an extensive documentation of Normandy, following Bayard's paths and giving a good indication of what such a mission might have accomplished.

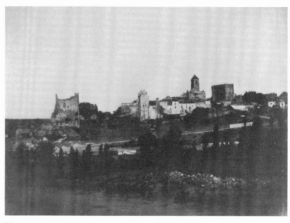

31
GUSTAVE LEGRAY
Chauvigny (Vienne)
1851
Calotype
26.3 x 36.7 cm
78:0649:5

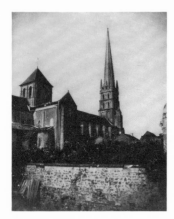

32
(GUSTAVE LEGRAY)
Saint-Savin (Vienne)
ca. 1851
Calotype
37.6 x 30.1 cm
78:0649:6

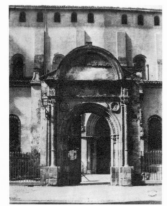

30
O. MESTRAL and/or GUSTAVE
LEGRAY
Toulouse (Haute-Garonne) Church
of Saint-Sernin
1851
Calotype
29.8 x 24.0 cm
78:0649:15
Provenance: Gabriel Cromer
Collection

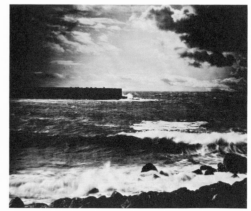

33
GUSTAVE LEGRAY
(Seascape)
ca. 1855
Albumen print from wet-collodion
negative
34.8 x 41.5 cm
82:1589:1
Provenance: Gabriel Cromer
Collection

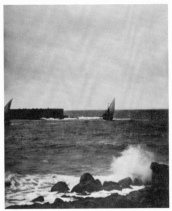

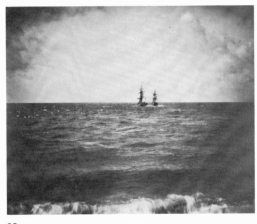

34
GUSTAVE LEGRAY
(Seascape with boat)
ca. 1855
Albumen print from wet-collodion
 negative
40.6 x 33.5 cm
81:1443:1

35
GUSTAVE LEGRAY
(Seascape)
ca. 1855
Albumen print from wet collodion
 negative
32.5 x 41.5 cm
81:1169:1
Provenance: Gabriel Cromer
 Collection

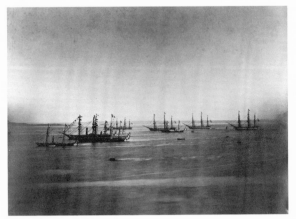

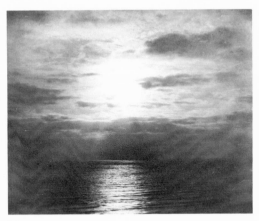

36
GUSTAVE LEGRAY
(Seascape with ships)
ca. 1855
Albumen print from wet collodion
 negative
30.0 x 41.3 cm
81:1441:1
Gift of Mrs. Kenneth Safe

37
GUSTAVE LEGRAY
(Seascape)
ca. 1855
Albumen print from wet collodion
 negative
30.0 x 37.8 cm
81:1442:1
Provenance: Gabriel Cromer
 Collection

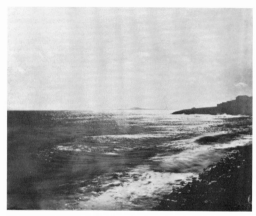

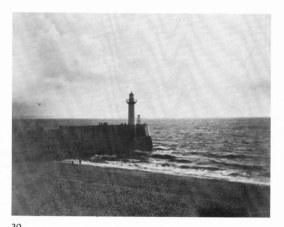

38
GUSTAVE LEGRAY
(Seascape)
ca. 1855
Albumen print from wet collodion
 negative
67:0116:2
Museum purchase

39
GUSTAVE LEGRAY
(Seascape with lighthouse)
ca. 1855
Albumen print from wet collodion
 negative
31.1 x 41.7 cm
67:0116:1
Museum purchase

40
HENRI LESECQ
Château de Hokanisbourg
1851
Calotype
33.2 x 23.1 cm
81:1465:17
Museum purchase

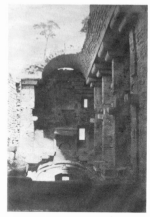

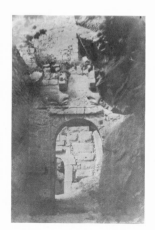

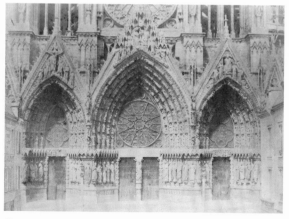

41
HENRI LESECQ
Château de Hokanisbourg
1851
Calotype
32.3 x 22.8 cm
81:1465:48
Museum purchase

42
HENRI LESECQ
Château de Hokanisbourg
1851
Calotype
32.8 x 22.1 cm
81:1465:52
Museum purchase

43
HENRI LESECQ
Reims Cathedral
ca. 1851
Calotype
25.3 x 34.7 cm
81:1465:12
Museum purchase

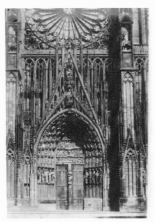

44
HENRI LESECQ
Strasbourg Cathedral
1851
Calotype
33.3 x 22.8 cm
81:1465:24
Museum purchase

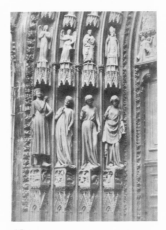

45
HENRI LESECQ
Strasbourg Cathedral
1851
Calotype
31.2 x 23.0 cm
81:1465:60
Museum purchase

46
HENRI LESECQ
Chartres Cathedral, general
 view, from *Fragments
 d'architecture et sculpture de la
 Cathédrale de Chartres*
1852 (negative)
Photogravure (Thiel ainé et
 Cie) from paper negative
35.0 x 25.0 cm
79:2634:8
Museum purchase

47
HENRI LESECQ
Chartres Cathedral, detail,
 from *Fragments d'architecture et
 sculpture de la Cathédrale de
 Chartres*
1852 (negative)
Photogravure (Thiel ainé et
 Cie) from paper negative
32.8 x 23.7 cm
79:2634:14
Museum purchase

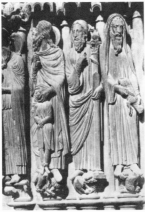

48
HENRI LESECQ
Chartres Cathedral, detail,
 from *Fragments d'architecture et
 sculpture de la Cathédrale de
 Chartres*
1852 (negative)
Photogravure (Thiel ainé et
 Cie) from paper negative
33.3 x 23.8 cm
79:2634:4
Museum purchase

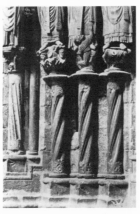

49
HENRI LESECQ
Chartres Cathedral, detail,
 from *Fragments d'architecture et
 sculpture de la Cathédrale de
 Chartres*
1852
Photogravure (Thiel ainé et
 Cie) from paper negative
33.7 x 23.2 cm
79:2634:2
Museum purchase

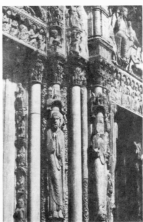

50
HENRI LESECQ
Chartres Cathedral, detail
ca. 1851
Cyanotype from paper
 negative
32.5 x 21.2 cm
81:1465:6
Museum purchase

51
HENRI LESECQ
(Chartres, unidentified door)
ca. 1851
Cyanotype from paper
 negative
32.2 x 21.3 cm
81:1465:4
Museum purchase

52 *(cover illustration)*
HENRI LESECQ
(Rustic scene, probably a cave
 dwelling near St. Leu)
ca. 1852
Cyanotype from paper
 negative
21.7 x 32.2 cm
81:1465:7
Museum purchase

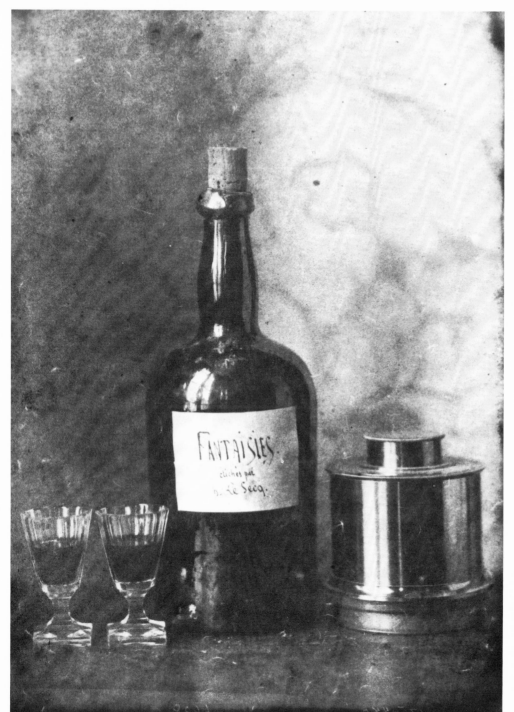

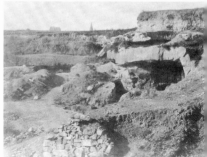

53
HENRI LESECQ
St. Leu (view of the caves)
1851
Calotype
23.2 x 30.8 cm
81:1465:30
Museum purchase

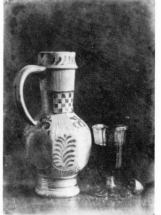

54
HENRI LESECQ
(Still life with bottle, glasses, and
 lens)
ca. 1855 (negative)
Modern print (1930) from paper
 negative
34.4 x 25.4 cm
81:1481:4
Provenance: Gabriel Cromer
 Collection

55
HENRI LESECQ
(Still life with jug)
ca. 1855 (negative)
Modern print (1930) from paper
 negative
35.3 x 26.0 cm
81:1481:10
Provenance: Gabriel Cromer
 Collection

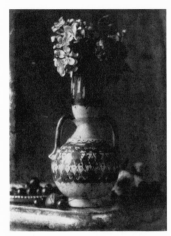

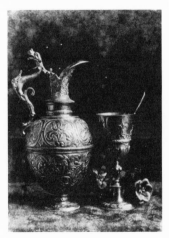

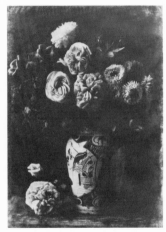

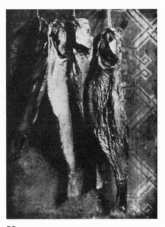

56
HENRI LESECQ
(Still life with flower bouquet)
ca. 1855 (negative)
Modern print (1974) from paper
 negative
35.3 x 26.0 cm
81:1481:13MP

57
HENRI LESECQ
(Still life with metal pitcher and
 goblet)
ca. 1855 (negative)
Modern print (1930) from paper
 negative
35.0 x 25.1 cm
81:1481:6
Provenance: Gabriel Cromer
 Collection

58
HENRI LESECQ
(Still life with flower bouquet)
ca. 1855 (negative)
Modern print (1930) from paper
 negative
35.3 x 25.6 cm
81:1481:2
Provenance: Gabriel Cromer
 Collection

59
HENRI LESECQ
(Still life with four fish)
ca. 1855 (negative)
Modern print (1930) from paper
 negative
35.2 x 25.5 cm
81:1481:12
Provenance: Gabriel Cromer
 Collection

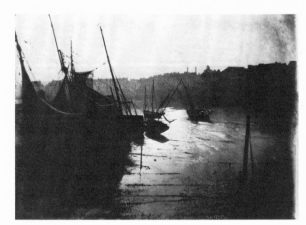

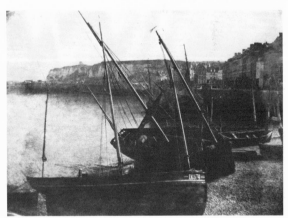

60
HENRI LESECQ
(Boats at Dieppe)
ca. 1855 (negative)
Modern print (1930) from paper
 negative
24.0 x 34.2 cm
81:1481:8
Provenance: Gabriel Cromer
 Collection

61
HENRI LESECQ
(Boats at Dieppe)
ca. 1855 (negative)
Modern print (1930) from paper
 negative
24.5 x 34.3 cm
81:1481:7
Provenance: Gabriel Cromer
 Collection

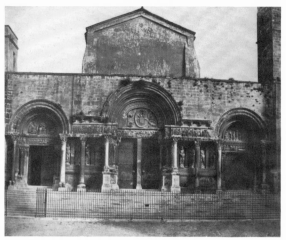

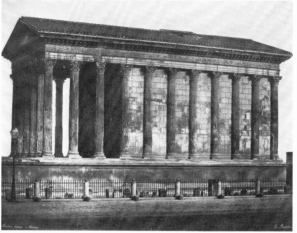

62
EDOUARD BALDUS
Eglise St. Gilles
1854
Salted paper print
35.6 x 44.0 cm
74:0050:16
Provenance: A. E. Marshall
 Collection
Museum purchase

63
EDOUARD BALDUS
Nîmes, Maison Carreé, No. 9
ca. 1851-1855
Salted paper print?
33.8 x 44.0 cm
74:0050:17

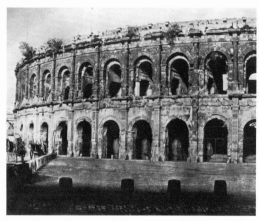

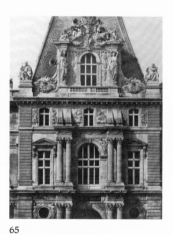

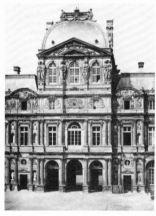

64
EDOUARD BALDUS
Nîmes, Amphithéâtre
ca. 1851-1855
Albumen print?
42.9 x 33.8 cm
74:0050:18
Museum purchase

65
EDOUARD BALDUS
The Louvre, Colbert Pavillon
ca. 1857-1858
Albumen print from glass
 negative?
38.8 x 34.0 cm
74:0050:33
Provenance: Gabriel Cromer
 Collection

68
EDOUARD BALDUS
The Louvre
ca. 1857-1858
Albumen print from glass
 negative?
43.8 x 33.4 cm
74:0050:12
Provenance: Gabriel Cromer
 Collection

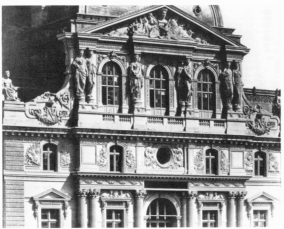

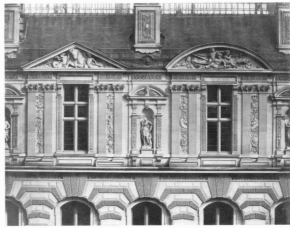

66
EDOUARD BALDUS
The Louvre
ca. 1857-1858
Salted paper print from glass
 negative?
33.5 x 43.6 cm
74:0050:8

67
EDOUARD BALDUS
The Louvre, detail
ca. 1857-1858
Albumen print from glass negative?
33.6 x 44.1 cm
74:0050:1
Provenance: Gabriel Cromer
 Collection

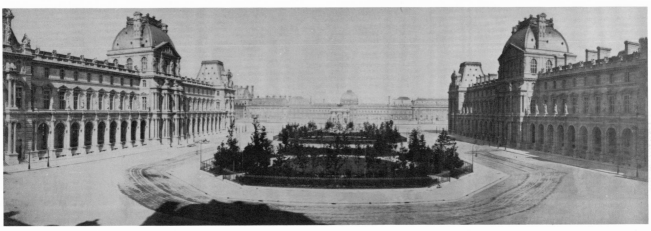

69
EDOUARD BALDUS
(Panorama of the Louvre and the
 Tuileries)
ca. 1861
Albumen print from glass negative
58.0 x 19.3 cm
76:0104:1
Museum purchase

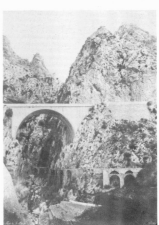

70
EDOUARD BALDUS
Pont de St. Louis près Menton,
 No. 93
ca. 1855
Salted paper print?
30.9 x 42.5 cm
81:3234:4
Provenance: Gabriel Cromer
 Collection

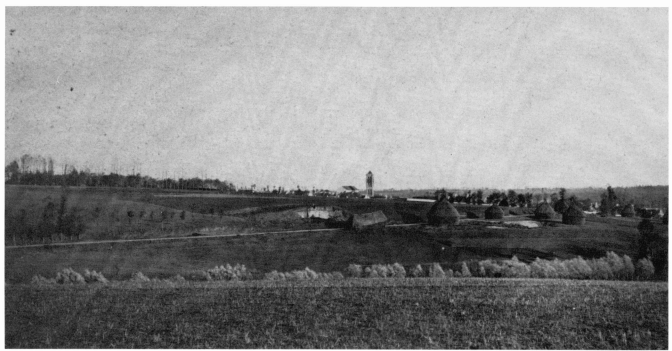

73
(EDOUARD BALDUS)
Louvres, Vues Générale, Visible du
 Chemin de fer (à l'Est), from the
 album *Chemin de Fer du Nord,*
 Ligne de Paris à Compiègne par
 Chantilly
ca. 1853
Albumen print?
8.0 x 16.0 cm
74:0053:14
Provenance: Gabriel Cromer
 Collection

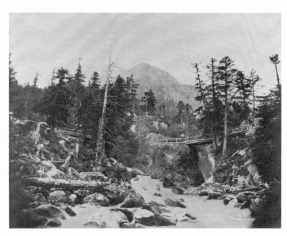

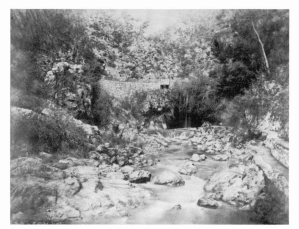

71
EDOUARD BALDUS
Pont d'Espagne à Canterets
ca. 1855
Treated salted paper?, retouched
33.3 x 43.5 cm
81:3234:2
Provenance: Gabriel Cromer
 Collection

72
EDOUARD BALDUS
Grotte de St. André, No. 102
ca. 1855
Salted paper print
32.9 x 44.5 cm
74:0050:9
Provenance: Gabriel Cromer
 Collection

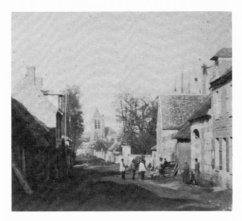

73a
(EDOUARD BALDUS)
Entre Verberie et Compiègne,
 Eglise du Meux, Eloignée du
 Chemin de fer (à l'Ouest), from
 the album *Chemin de Fer du Nord,
 Ligne de Paris à Compiègne par
 Chantilly*
ca. 1853
Albumen print?
6.7 x 7.5 cm
74:0053:71
Provenance: Gabriel Cromer
 Collection

73b
(EDOUARD BALDUS)
Entre Louvres et Orry-la-Ville,
 Pont de la Garenne à
 Morfontaine, Eloigné du
 Chemin de fer (à l'Est), from the
 album *Chemin de Fer du Nord,
 Ligne de Paris à Compiègne par
 Chantilly*
ca. 1853
Albumen print
7.0 x 7.0 cm
74:0053:16
Provenance: Gabriel Cromer
 Collection

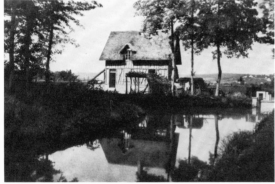

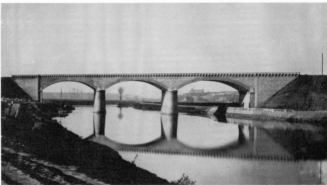

74
EDOUARD BALDUS
Chalet à Enghein, from the album
 *Chemin de Fer du Nord, Ligne de
 Paris à Boulogne,*
ca. 1855-1860
Salted paper print
26.0 x 39.5 cm
74:0051:6
Provenance: Gabriel Cromer
 Collection

75
EDOUARD BALDUS
Pont sur l'Oise près Creil, from the
 album *Chemin de Fer du Nord,
 Ligne de Paris à Boulogne,*
ca. 1855-1860
Albumen print
21.7 x 40.0 cm
74:0051:23
Provenance: Gabriel Cromer
 Collection

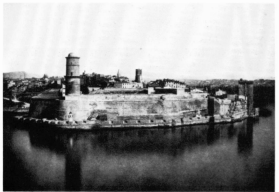

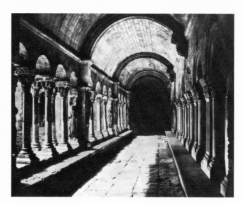

76
EDOUARD BALDUS
Marseille, from the album *Chemins
de Fer de Paris à Lyon à la
Méditerannée*
ca. 1855
Albumen print?
27.3 x 41.0 cm
74:0055:59
Museum purchase

76a
EDOUARD BALDUS
Arles, Cloître St. Trophime, from
the album *Chemins de Fer de Paris
à Lyon à la Méditerannée*
ca. 1855
Salted paper print?
33.1 x 42.0 cm
74:0055:47
Museum purchase

77 *(not illustrated)*
EDOUARD BALDUS
Louvre, Cour Intérieure
ca. 1869
Héliogravure (E. Baldus)
31.2 x 42.8 cm
74:0050:26

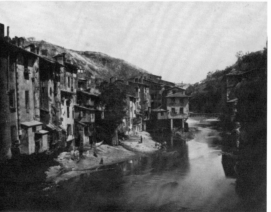

76b
EDOUARD BALDUS
Toulon, from the album *Chemins de
Fer de Paris à Lyon à la
Méditerannée*
ca. 1855
Albumen print?
27.7 x 43.3 cm
74:0055:71
Museum purchase

76c
EDOUARD BALDUS
Vienne, St. Jean, from the album
*Chemins de Fer de Paris à Lyon à la
Méditerannée*
ca. 1855
Albumen print
32.0 x 42.7 cm
74:0055:12
Museum purchase

78 *(not illustrated)*
EDOUARD BALDUS
Ministère d'Etat, Salon Thèâtre,
from *Palais du Louvre et des
Tuileries*
ca. 1869
Héliogravure (E. Baldus)
16.8 x 24.0 cm
82:1397:6
Museum purchase

III. Reproduction, Publication, Experimentation

Baldus was not the only photographer, and certainly not the first, to experiment with photogravure techniques. Such investigations began in the earliest years of the new medium with daguerreans Alfred Donné and Hippolyte Fizeau. Niépce de Saint-Victor, Nègre (80-81) and Alphonse Poitevin (82-83) also tried their hand. There were two issues that prompted this continuous activity: one was the desire to produce multiple copies of a single picture and to make that compatible with the printed page, the other was to create a print that was not susceptible to fading.

In an effort—quite successful—to print non-fading photographs to tip into publications, Louis Désiré Blanquart-Evrard of Lille established the first printing company for photographically illustrated books in 1851. His prints were not gravures, but chemically adjusted photographic proofs similar in appearance to normal salted paper prints. Blanquart-Evrard printed photographs for two books published by Gide and Baudry of Paris: Maxime DuCamp's *Egypt, Nubie, Palestine et Syrie*, 1852 (191-197) and Auguste Salzmann's *Jerusalem*, 1854 & 1856 (199-203). Most of these prints remain in their original pristine condition today. He published and printed another twenty-four odd folios during the period from 1851 to 1855, including *La Belgique* (84), *Bruxelles photographique* (85), *Souvenirs photographiques* (86-88), *Mélanges photographiques* (89-93), *L' Art Religieux* (94-96), and *Etudes photographiques* (97-99). The occupation, however, was not commercially viable. Attention returned to photogravure. In 1856, the Duc de Luynes established a prize for the best photomechanical process, which was eventually won by Poitevin (82-83). In 1864, the Duke's voyage to the "Orient" was photographed by Louis Vignes and the pictures reproduced by Nègre's photogravure process (81).

The massive amount of experimentation going on during this period is also noticeable in the so called "Blanquart-Evrard *Cahiers*", where various prints with different tonalities (as well as with and without added clouds), and salted paper prints and albumen prints from the same negative, abound (108-109).

Henri Fontan, of Douai, who was the source of the *Cahiers*, was convinced that they were the work books of Blanquart-Evrard, perhaps representing several grand projects as yet unfulfilled. Intriguing as the idea is, only circumstantial evidence exists. Douai is near Lille; many of the pictures are similar to those that the photographer is known to have published; and the nineteenth century list that accompanies the photographs is written in a hand not dissimilar to Blanquart-Evrard's.

Too, it is tempting to believe that the Normandy *Cahier* is the lost Bayard commission from 1851 (which was purportedly done with glass negatives) and indeed three images in the Bayard information file at Eastman House are identical to three in the *Cahiers*. But other identical prints have been labeled Poitevin. Both designations appear inconclusive at this time. We know at least that Bayard photographed Rouen cathedral and its *flèche* with

waxed paper negatives in 1851 and was experimenting with chemicals that created richly toned proofs similar to those of Blanquart-Evrard. We know also that once the 1851 missions were finished, the first thought of the critics was that the pictures should be made available through publication. Blanquart-Evrard's printing establishment came immediately to mind, but it seems that no arrangement to print the books was ever realized.

Other possibilities abound. Photographers who worked in Normandy include Ferdinand Tillard, Fortier, Mestral, Baron Richard de Prulay, Edmond Bacot, Julien Blot, and Louis Alphonse de Brébisson. The last two were at least friendly with the *Cahiers* photographer, because, according to the descriptive list (though the pictures themselves are missing), both posed for him in Falaise.

The series is thoroughly extraordinary both for its archaeological approach to the buildings and their details, and for the fact that it records sites that have been altered or completely destroyed in World War II. St. Lô, for instance (106-109), now known as the "capital of ruins", was 90% levelled in the Battle of St. Lô in 1944. What remains of the cathedral is glued together by modern brick. Not a stone in the general view (106) remains, nor does the beautiful house and bookstore of M. Letriguilly (108-109). Mont-Saint-Michel was photographed while it was a prison—far before the restorations and the tourists (115-116). Lisièux Cathedral, now also restored, was in tatters, with broken Gothic windows stopped up by stones and other debris, reminding us how necessary the 1851 Commission des Monuments Historiques survey really was. The abstract views and dizzying panoramas from atop houses and cathedral roofs, which crop up throughout the *Cahiers*, are as impressive as anything in the calotype medium (110-114).

The pictures represent Rouen, Louviers, Caen, St Lô, Darnatel, Bayeux, Argourge, Longue, Evreux, Lisièux, Coutances, Avranches, Falaise, Guibray, Chaumière, and Mont-Saint-Michel.

The Normandy *Cahier* ("Blanquart-Evrard *Cahiers* 1 and 2") were accompanied by three others (3, 4 and 5), less well documented, and identified in a different hand. *Cahier* 3 includes pictures of Orleans, Château de Chambord, Château de Blois, Paris and Belgium, including a series of pictures recording the specially decorated arches erected to commemorate the reign of Leopold I (128-135). *Cahier* 4 with unidentified Gothic church ruins (126) and landscapes (149-150, 156, 159-160), is partly illustrated below in the "Landscape" section.

Especially interesting are the photos in *Cahier* 5, which include several pictures of the Honfleur marine (124-125) and some signed landscapes by Baillieu d'Avrincourt (120-121). Baillieu d'Avrincourt was evidently a friend of de Brébisson, from Falaise (who posed in one of the Normandy *Cahier* pictures). They co-authored a photographic manual with others in 1859 (*Méthodes photographiques perfectionnées*, where Baillieu d'Avrincourt wrote on collodion). Arthur Chevalier introduced him:

Few amateurs are as zealous about photography as M. Baillieu d'Avrincourt, no one perhaps has produced as many prints as he and all his proofs are beautiful and taken with taste. They raise to a high degree the union of two qualities that alone can lead to perfection: 1st, sureness and ability in manipulations; 2nd, artistic sentiment.[8]

Perhaps he was responsible for the entire *Cahier* series, including the Normandy pictures.

Another photographer active in Normandy was Edmond Bacot, first from Caen, then Lion-sur-Mer. It is Bacot who was Charles Hugo's link to photography, and the latter, with Auguste Vacquerie, who was responsible for the Jersey Victor Hugo album (136-137). The photograph of Victor Hugo's hand (137) is one of dozens of beautiful studies assembled together by the Hugo family for presentation to a family friend, Euphémie Barbier.

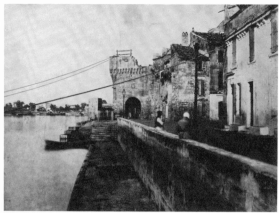

79
CHARLES NEGRE
Arles, Porte des Châtaignes
ca. 1852
Calotype
23.3 x 32.0 cm
80:0521:1

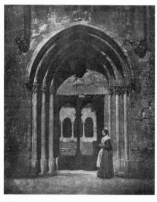

80
(CHARLES NEGRE)
Le Portail de Saint-Trophime
ca. 1855
Photogravure (Nègre)
17.4 x 15.0 cm
80:0520:1
Provenance: Gabriel Cromer
 Collection

82
UNIDENTIFIED
 PHOTOGRAPHER
 (?ALPHONSE POITEVIN)
Haram-ech-Chérif, Mur de
 Manassès, Enciente d'Ophel
ca. 1857 or after
Photolithograph, procédé Poitevin
 (Lemercier)
24.0 x 32.0 cm
81:3267:2
Gift of Dr. Walter Clark

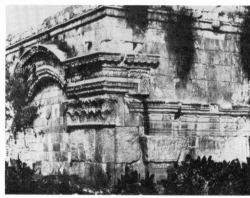

83
UNIDENTIFIED
 PHOTOGRAPHER
 (?ALPHONSE POITEVIN)
Harem-ech-Chérif, Porte Dorée, à
 l'Interieur du Haram-ech-Chérif
Photolithograph, procédé Poitevin
 (Lemercier)
24.3 x 32 cm
81:3267:1
Gift of Dr. Walter Clark

81 *(not illustrated)*
(LOUIS VIGNES)
Semoak
(1864, negative)
Photogravure (Nègre)
19.3 x 24.2 cm
70:0083:1
Provenance: Gabriel Cromer
 Collection

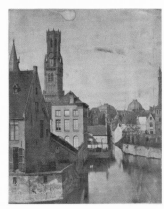

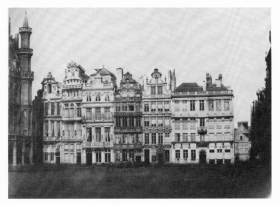

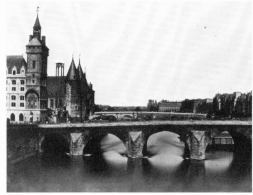

84
DESPLANQUES
Vue Prise à Bruges, from *La Belgique*, Louis-Désiré Blanquart-Evrard, editor
ca. 1854
Salted paper print
45.4 x 38.0 cm
78:0650:1

85
GUILLAUME DECLAINE
Maisons des Corporations sur la Grand Place, from *Bruxelles Photographique*, Louis-Désiré Blanquart-Evrard, editor
ca. 1852-1854
Salted paper print
31.9 x 45.3 cm
81:1101:3

86
FORTIER
Vue prise du Pont Notre-Dame, à Paris, from *Souvenirs Photographiques*, Louis-Désiré Blanquart-Evrard, editor
ca. 1850-1853
Salted paper print
18.5 x 24.7 cm
81:1107:3
Provenance: Alden Scott Boyer Collection

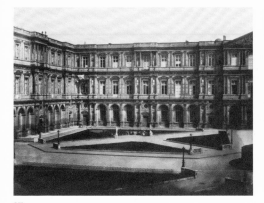

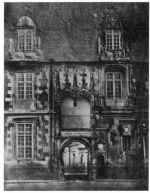

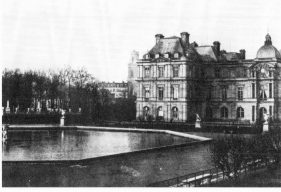

87
FORTIER
Intérieur de la cour du Louvre, from *Souvenirs Photographiques*, Louis-Désiré Blanquart-Evrard, editor
ca. 1850-1853
Salted paper print
19.5 x 25.0 cm
81:1107:2
Provenance: Alden Scott Boyer Collection

88
FORTIER
Entrée du Château de Blois, from *Souvenirs Photographiques*, Louis-Désiré Blanquart-Evrard, editor
ca. 1850-1853
Salted paper print
24.7 x 19.2 cm
81:1107:4
Provenance: Alden Scott Boyer Collection

89
UNIDENTIFIED PHOTOGRAPHER
Palais et Jardin du Luxembourg à Paris, from *Mélanges photographiques*, Louis-Désiré Blanquart-Evrard, editor
ca. 1851
Salted paper print
14.7 x 21.1 cm
81:1109:8
Museum purchase

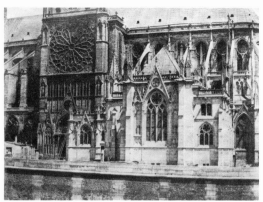

90
UNIDENTIFIED
 PHOTOGRAPHER
Nouvelle Sacristie de Notre-Dame,
 from *Mélanges photographiques*,
 Louis-Désiré Blanquart-Evrard,
 editor
ca. 1851
Salted paper print
15.3 x 20.8 cm
81:1109:3
Museum purchase

91
CHARLES MARVILLE
Cabane des Moutons au jardin des
 Plantes à Paris, from *Mélanges
 photographiques*, Louis-Désiré
 Blanquart-Evrard, editor
ca. 1851
Salted paper print
15.6 x 20.7 cm
81:1108:6
Provenance: Alden Scott Boyer
 Collection

92
CHARLES MARVILLE
Portique du Château d'Anet, from
 Mélanges photographiques,
 Louis-Désiré Blanquart-Evrard,
 editor
ca. 1851
Salted paper print
21.0 x 14.2 cm
81:1108:4
Provenance: Alden Scott Boyer
 Collection

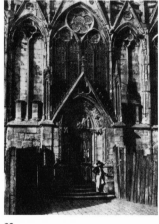

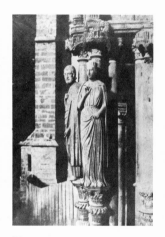

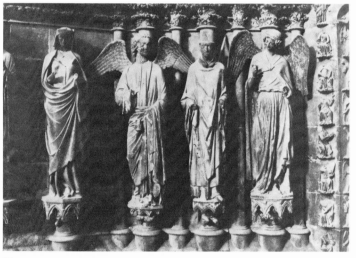

93
CHARLES MARVILLE
La Porte Rouge, from *Mélanges
 photographiques*, Louis-Désiré
 Blanquart-Evrard, editor
ca. 1851
Salted paper print
21.0 x 15.5 cm
81:1117:1

94
CHARLES MARVILLE
Cathédral de Chartres, Grandes
 Figures des Pilastres du Portail
 Septentrional, from *L'Art
 Religieux, XIIe Siècle*,
 Louis-Désiré Blanquart-Evrard,
 editor
ca. 1853-1855
Salted paper print
36.0 x 25.5 cm
81:1530:8
Provenance: Gabriel Cromer
 Collection

95
CHARLES MARVILLE
Cathédral de Reims, figures du
 Grand Portail, from *L'Art
 Religieux, XIIIe Siècle*,
 Louis-Désiré Blanquart-Evrard,
 editor
ca. 1853-1854
Salted paper print
25.2 x 35.8 cm
81:1530:6
Provenance: Gabriel Cromer
 Collection

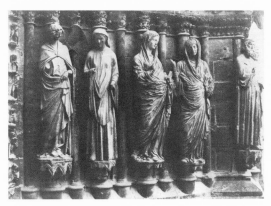

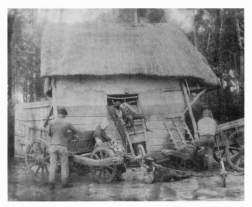

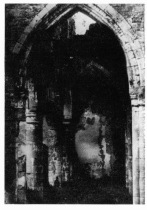

96
CHARLES MARVILLE
Cathédral de Reims, figures du
 grand portail, from *L'Art
 Religieux, XIIIe Siècle*,
 Louis-Désiré Blanquart-Evrard,
 editor
ca. 1853-1855
Salted paper print
25.0 x 35.0 cm
81:1101:1
Provenance: Gabriel Cromer
 Collection

97
UNIDENTIFIED
 PHOTOGRAPHER
(Farm view with workers resting),
 from *Etudes photographiques*,
 Louis-Désiré Blanquart-Evrard,
 editor
ca. 1853
Salted paper print
18.1 x 23.3 cm
81:1100:3
Provenance: Alden Scott Boyer
 Collection

99
A. FAYS
(Gothic ruin), from *Etudes
 photographiques*, Louis-Désiré
 Blanquart-Evrard, editor
ca. 1853
Salted paper print
20.6 x 15.4 cm
81:1099:1

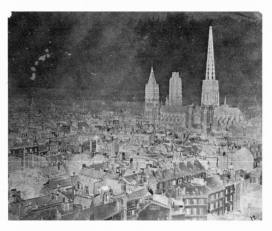

98
UNIDENTIFIED
 PHOTOGRAPHER
(Landscape with trees and snow),
 from *Etudes photographiques*,
 Louis-Désiré Blanquart-Evrard,
 editor
ca. 1853
Salted paper print
24.0 x 17.5 cm
81:1100:2
Provenance: Alden Scott Boyer
 Collection

100
UNIDENTIFIED
 PHOTOGRAPHER
(LOUIS-DESIRE
 BLANQUART-EVRARD
 CAHIER 1)
Rouen, Vue panoramique de la
 Cathédrale
ca. 1850-1855
Waxed paper negative
20.5 x 25.8 cm
81:3198:46
Provenance: Henri Fontan

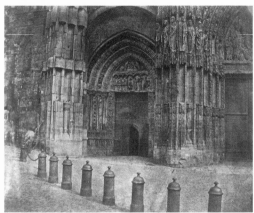

101
UNIDENTIFIED
 PHOTOGRAPHER
 (LOUIS-DESIRE
 BLANQUART-EVRARD
 CAHIER 1)
Rouen, Portail gauche de la
 Cathédrale
ca. 1851-1855
Salted paper print
21.3 x 26.6 cm
81:1110:1
Provenance: Henri Fontan

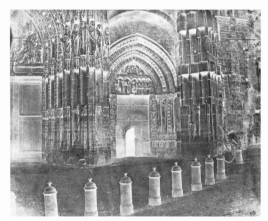

102
UNIDENTIFIED
 PHOTOGRAPHER
 (LOUIS-DESIRE
 BLANQUART-EVRARD
 CAHIER 1)
Rouen, Portail gauche de la
 Cathédrale
ca. 1850-1855
Waxed paper negative
26.8 x 21.5 cm
81:3198:43
Provenance: Henri Fontan

103
UNIDENTIFIED
 PHOTOGRAPHER
 (LOUIS-DESIRE
 BLANQUART-EVRARD
 CAHIER 1)
Façade et Tourelle du Palais de
 Justice, architecture gothique de
 la renaissance, 1493
ca. 1851-1855
Albumen print
26.5 x 20.0 cm
81:1110:10
Provenance: Henri Fontan

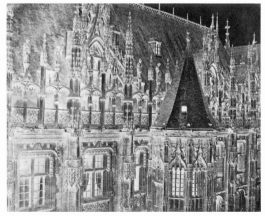

104
UNIDENTIFIED
 PHOTOGRAPHER
 (LOUIS-DESIRE
 BLANQUART-EVRARD
 CAHIER 1)
Rouen, Palais de Justice
ca. 1850-1855
Waxed paper negative
26.5 x 20.9 cm
81:3198:40
Provenance: Henri Fontan

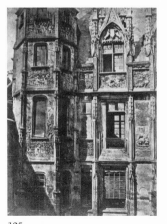

105
UNIDENTIFIED
 PHOTOGRAPHER
 (LOUIS-DESIRE
 BLANQUART-EVRARD
 CAHIER 1)
Interieur de l'hôtel de
 Bourtheroulde sur la place où la
 pucelle d'Orleans fut brulée en
 1431. L'hôtel date du 16e siècle.
ca. 1851-1855
Albumen print
26.3 x 19.8 cm
81:1110:5
Provenance: Henri Fontan

106
UNIDENTIFIED
 PHOTOGRAPHER
 (LOUIS-DESIRE
 BLANQUART-EVRARD
 CAHIER 2)
Hôtel de Ville de St. Lô
ca. 1850-1855
Waxed paper negative
21.2 x 26.8 cm
81:3203:40
Provenance: Henri Fontan

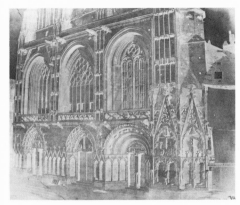

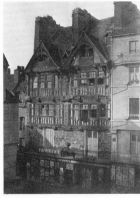

107
UNIDENTIFIED
 PHOTOGRAPHER
 (LOUIS-DESIRE
 BLANQUART-EVRARD
 CAHIER 2)
Cathédrale de St. Lô, XV Siècle
ca. 1850-1855
Waxed paper negative
26.8 x 21.5 cm
81:3203:33
Provenance: Henri Fontan

108 (not illustrated)
UNIDENTIFIED
 PHOTOGRAPHER
 (LOUIS-DESIRE
 BLANQUART-EVRARD
 CAHIER 2)
Maison en bois occupé par Mr
 Letriguilly, Libraire, St. Lô
ca. 1851-1855
Calotype
26.3 x 20.8 cm
81:1112:1
Provenance: Henri Fontan

108a
UNIDENTIFIED
 PHOTOGRAPHER
 (LOUIS-DESIRE
 BLANQUART-EVRARD
 CAHIER 2)
Maison en bois occupé par Mr
 Letriguilly, Libraire, St. Lô
ca. 1851-1855
Albumen print or treated salted
 paper print
26.9 x 20.6 cm
81:1112:2
Provenance: Henri Fontan

109
UNIDENTIFIED
 PHOTOGRAPHER
 (LOUIS-DESIRE
 BLANQUART-EVRARD
 CAHIER 2)
Maison en bois occupé par Mr
 Letriguilly, Libraire, St. Lô
ca. 1851-1855
Albumen print?
26.8 x 21.1 cm
81:1112:6
Provenance: Henri Fontan

110
UNIDENTIFIED
 PHOTOGRAPHER
 (LOUIS-DESIRE
 BLANQUART-EVRARD
 CAHIER 1)
Clocheton—Candelabre de St.
 Pierre de Caen
ca. 1851-1855
Albumen print
26.6 x 20.1 cm
81:1110:17
Provenance: Henri Fontan

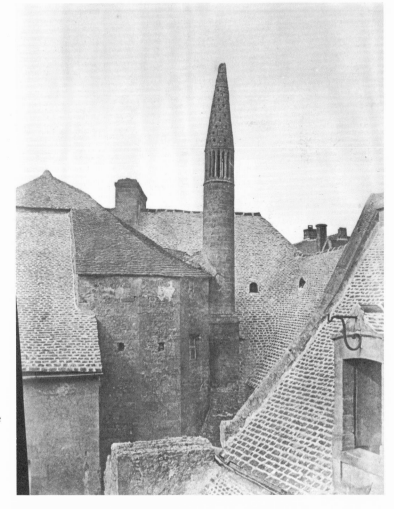

111
UNIDENTIFIED
 PHOTOGRAPHER
 (LOUIS-DESIRE
 BLANQUART-EVRARD
 CAHIER 2)
Phare du Lanterne des Morts de
 l'ancien cimitière de Bayeux
ca. 1851-1855
Albumen print
26.1 x 20.5 cm
81:1112:7
Provenance: Henri Fontan

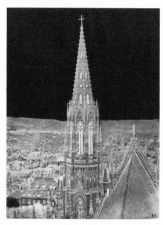

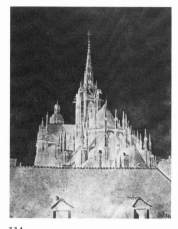

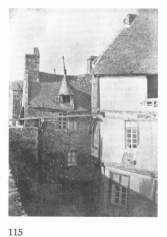

112
UNIDENTIFIED
 PHOTOGRAPHER
 (LOUIS-DESIRE
 BLANQUART-EVRARD
 CAHIER 2)
Partie du clocher de l'église St.
 Jean à Caen
ca. 1850-1855
Waxed paper negative
26.8 x 20.5 cm
81:3203:49
Provenance: Henri Fontan

113
UNIDENTIFIED
 PHOTOGRAPHER
 (LOUIS-DESIRE
 BLANQUART-EVRARD
 CAHIER 1)
Une des deux flèches de l'église de
 St. Ouen, 66 mètres de hauteur
ca. 1850-1855
Waxed paper negative,
 hand-touched sky
27.1 x 21.0 cm
81:3198:19
Provenance: Henri Fontan

114
UNIDENTIFIED
 PHOTOGRAPHER
 (LOUIS-DESIRE
 BLANQUART-EVRARD
 CAHIER 1)
Vue de la Cathédral d'Evreux prise
 des appartements du gd. vicaire
ca. 1850-1855
Paper negative
25.6 x 20.6 cm
81:3203:15
Provenance: Henri Fontan

115
UNIDENTIFIED
 PHOTOGRAPHER
 (LOUIS-DESIRE
 BLANQUART-EVRARD
 CAHIER 2)
Mont-Saint-Michel, Maison à
 l'entrée de la rue principale
ca. 1851-1855
Albumen print or treated salted
 paper print
27.0 x 20.8 cm
81:1112:9
Provenance: Henri Fontan

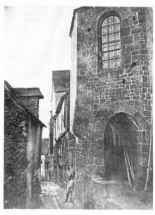

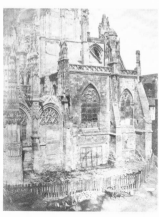

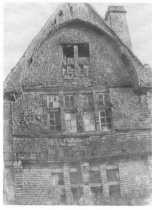

116
UNIDENTIFIED
 PHOTOGRAPHER
 (LOUIS-DESIRE
 BLANQUART-EVRARD
 CAHIER 2)
Mont-Saint-Michel, Derrière de
 l'église
ca. 1851-1855
Albumen print or treated salted
 paper print
81:1112:8
Provenance: Henri Fontan

117
UNIDENTIFIED
 PHOTOGRAPHER
 (LOUIS-DESIRE
 BLANQUART-EVRARD
 CAHIER 1)
Eglise de Louviers
ca. 1851-1855
Albumen print
25.5 x 20.5 cm
81:1110:6
Provenance: Henri Fontan

118
UNIDENTIFIED
 PHOTOGRAPHER
 (LOUIS-DESIRE
 BLANQUART-EVRARD
 CAHIER 4)
(Ruined wooden house)
ca. 1851-1855
Albumen print
26.6 x 20.2 cm
81:1115:17
Provenance: Henri Fontan

119
UNIDENTIFIED
 PHOTOGRAPHER
 (LOUIS-DESIRE
 BLANQUART-EVRARD
 CAHIER 5)
(Forest scene)
ca. 1851-1855
Albumen print?
26.2 x 20.8 cm
81:1116:2
Provenance: Henri Fontan

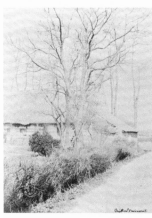 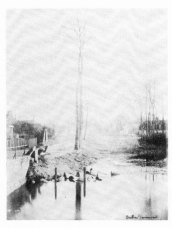 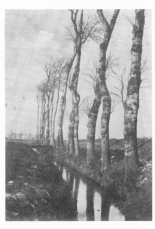 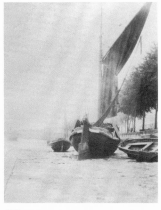

120
BALLIEU D'AVRINCOURT
(LOUIS-DESIRE
 BLANQUART-EVRARD
 CAHIER 5)
(Landscape)
ca. 1851-1855
Albumen print
24.9 x 19.5 cm
81:1116:6
Provenance: Henri Fontan

121
BALLIEU D'AVRINCOURT
(LOUIS-DESIRE
 BLANQUART-EVRARD
 CAHIER 5)
(Landscape)
ca. 1851-1855
Albumen print
23.8 x 19.4 cm
81:1116:5
Provenance: Henri Fontan

122
UNIDENTIFIED
 PHOTOGRAPHER
(LOUIS-DESIRE
 BLANQUART-EVRARD
 CAHIER 5)
(Landscape)
ca. 1851-1855
Salted paper print
25.3 x 18.8 cm
81:1116:15
Provenance: Henri Fontan

124
UNIDENTIFIED
 PHOTOGRAPHER
(LOUIS-DESIRE
 BLANQUART-EVRARD
 CAHIER 5)
(Boat scene, perhaps Honfleur)
ca. 1851-1855
Albumen print
25.6 x 19.8 cm
81:1116:11
Provenance: Henri Fontan

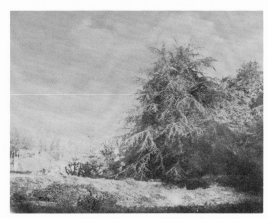 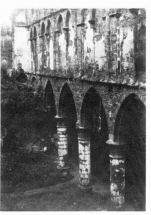

123
UNIDENTIFIED
 PHOTOGRAPHER
(LOUIS-DESIRE
 BLANQUART-EVRARD
 CAHIER 5)
(Landscape)
ca. 1851-1855
Albumen print
20.4 x 25.8 cm
81:1116:1
Provenance: Henri Fontan

126
UNIDENTIFIED
 PHOTOGRAPHER
(LOUIS-DESIRE
 BLANQUART-EVRARD
 CAHIER 4)
(Ruined Gothic church)
ca. 1851-1855
Albumen print?
27.5 x 20.6 cm
81:1115:16
Provenance: Henri Fontan

125
UNIDENTIFIED
 PHOTOGRAPHER
(LOUIS-DESIRE
 BLANQUART-EVRARD
 CAHIER 5)
(Boat scene, perhaps Honfleur)
ca. 1851-1855
Albumen print?
25.8 x 20.2 cm
81:1116:10
Provenance: Henri Fontan

127
T.T.H.
(Temporary entrance arch for the
 Empress)
ca. 1855
Calotype
19.1 x 23.1 cm
70:0049:38
Provenance: Gabriel Cromer
 Collection; Napoleon III

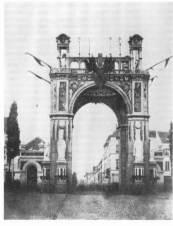

128
UNIDENTIFIED
 PHOTOGRAPHER
(LOUIS-DESIRE
 BLANQUART-EVRARD
 CAHIER 3)
(Triumphal arch, in Belgium, to
 commemorate the reign of
 Leopold I)
1856
Albumen print
23.3 x 18.5 cm
81:1114:13
Provenance: Henri Fontan

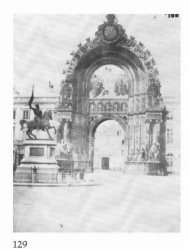

129
UNIDENTIFIED
 PHOTOGRAPHER
(LOUIS-DESIRE
 BLANQUART-EVRARD
 CAHIER 3)
Belgique, Porte historique (to
 commemorate the reign of
 Leopold I)
1856
Albumen print
23.0 x 18.6 cm
81:1114:14
Provenance: Henri Fontan

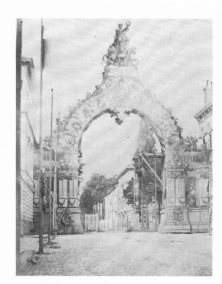

130
UNIDENTIFIED
 PHOTOGRAPHER
(LOUIS-DESIRE
 BLANQUART-EVRARD
 CAHIER 3)
Arc de Triomph en Belgique, 21
 juillet 1856, pour commemorer
 l'inauguration ou regne de
 Leopold 1 être roi pour le
 Congrés le 4 juin 1831
1856
Albumen print
23.7 x 18.9 cm
81:1114:17
Provenance: Henri Fontan

131
UNIDENTIFIED
 PHOTOGRAPHER
(LOUIS-DESIRE
 BLANQUART-EVRARD
 CAHIER 3)
Reposoir en Belgique
ca. 1851-1855
Albumen print
25.5 x 20.0 cm
81:1114:16
Provenance: Henri Fontan

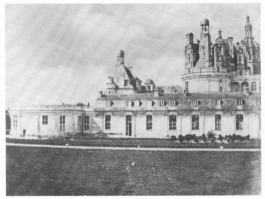

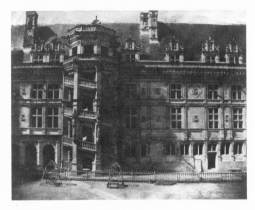

132
UNIDENTIFIED
 PHOTOGRAPHER
(LOUIS-DESIRE
 BLANQUART-EVRARD
 CAHIER 3)
Château de Chambord
ca. 1851-1855
Salted paper print
20.2 x 26.2 cm
81:1114:5
Provenance: Henri Fontan

133
UNIDENTIFIED
 PHOTOGRAPHER
(LOUIS-DESIRE
 BLANQUART-EVRARD
 CAHIER 3)
Escalier du Château de Blois
ca. 1851-1855
20.8 x 26.0 cm
81:1114:6
Provenance: Henri Fontan

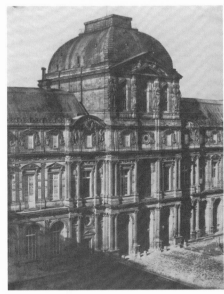

134
UNIDENTIFIED
 PHOTOGRAPHER
(LOUIS-DESIRE
 BLANQUART-EVRARD
 CAHIER 3)
Tuileries, Pavillion de l'Horloge
ca. 1851-1855
Salted paper print
26.5 x 21.0 cm
81:1114:4
Provenance: Henri Fontan

135
UNIDENTIFIED
 PHOTOGRAPHER
(LOUIS-DESIRE
 BLANQUART-EVRARD
 CAHIER 3)
(Street scene)
ca. 1851-1855
Salted paper print
20.2 x 26.2 cm
81:1114:9
Provenance: Henri Fontan

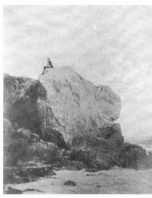

136
(CHARLES HUGO and/or
AUGUSTE VACQERIE)
(Victor Hugo on the rocks at
Jersey)
ca. 1855
Salted paper print, probably from
a hand-touched glass negative
19.2 x 16.1 cm
78:0648:1
Provenance: Gabriel Cromer
Collection

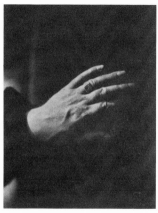

137
(CHARLES HUGO and/or
AUGUSTE VACQERIE)
(Hand of Victor Hugo), from
"The Victor Hugo Album"
ca. 1850-1855
Salted paper print
9.2 x 7.5 cm
79:0023:23
Provenance: Gabriel Cromer
Collection

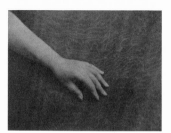

137a
(CHARLES HUGO and/or
AUGUSTE VACQERIE)
(Hand of Madame Hugo), from
"The Victor Hugo Album"
ca. 1850-1855
Salted paper print
6.4 x 8.6 cm
79:0023:10
Provenance: Gabriel Cromer
Collection

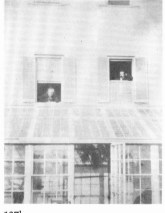

137b
(CHARLES HUGO and/or
AUGUSTE VACQERIE)
(Victor and Charles Hugo leaning
out two windows of the Hugo
house, Jersey), from "The Victor
Hugo Album"
ca. 1850-1855
Salted paper print
9.3 x 7.4 cm
79:0023:4
Provenance: Gabriel Cromer
Collection

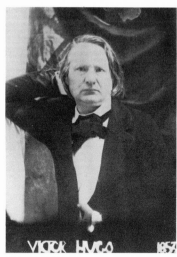

137c
(CHARLES HUGO and/or
AUGUSTE VACQERIE)
(Victor Hugo), from "The Victor
Hugo Album"
1853
Salted paper print
9.7 x 7.2 cm
79:0023:14
Provenance: Gabriel Cromer
Collection

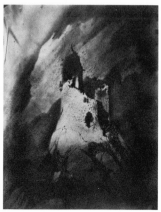

137d
(CHARLES HUGO and/or
AUGUSTE VACQERIE)
(Reproduction of a drawing by
Victor Hugo), from "The Victor
Hugo Album"
ca. 1850-1855
Salted paper print
9.3 x 7.2 cm
79:0023:28
Provenance: Gabriel Cromer
Collection

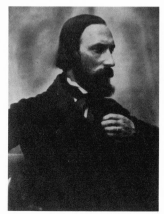

137e
(CHARLES HUGO and/or
AUGUSTE VACQERIE)
(Auguste Vacquerie), from
"The Victor Hugo Album"
ca. 1850-1855
Salted paper print
9.9 x 7.5 cm
79:0023:33
Provenance: Gabriel Cromer
Collection

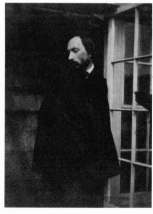

137f
(CHARLES HUGO and/or
AUGUSTE VACQERIE)
(Auguste Vacquerie), from
"The Victor Hugo Album"
ca. 1850-1855
Salted paper print
10.2 x 7.6 cm
79:0023:12
Provenance: Gabriel Cromer
Collection

IV. Landscape

Early photographers delighted in making landscapes, and basically these fall into two different groups. One is the more traditional type, with composition and subject matter similar to *plein-air* painting (138-143). The other is a more intimate, sometimes more photographic type, depicting farm scenes with ladders and wheelbarrows or garden implements (really an extended still life, 146-152). This second form includes not-so-traditional approaches to ordinary subject matter (145, 155).

The first style was greatly influenced by early practitioners like Adalbert Cuvelier (138-139). He was closely associated with a group of avant-garde artists in Arras, including Corot, and he and his son Eugène (who continued to exhibit calotypes until the 1870s) were in touch with Delacroix and the Barbizon painters as well. Marville, who excelled in landscape (140, 144) as much as architectural views and genre (91-96), was one of several Parisian photographers who frequented the forest of Fontainebleau, a favorite spot for painters like Théodore Rousseau, Diaz de la Peña, Corot, Millet, the Artoisien Dutilleux, and Courbet.

The second style—the farm scene and extended still life of garden tools—emerged early as a leit motif in photography with Bayard (3-4). *Amateur* calotypists (non-professionals like Victor Regnault, Henri LeSecq, etc.) were particularly fond of these kinds of images. They become part of the fabric of early photographic iconography, legitimizing for public consumption what painting had only infrequently and privately done in the past. It is this crucial shift, from boudoir to Salon, which makes photography a key factor in the rise of Impressionism.

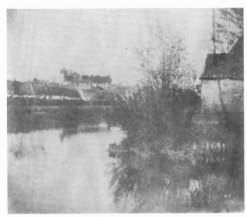

139
(ADALBERT CUVELIER)
(Landscape)
1852
Calotype
14.3 x 16.9 cm
82:1646:1

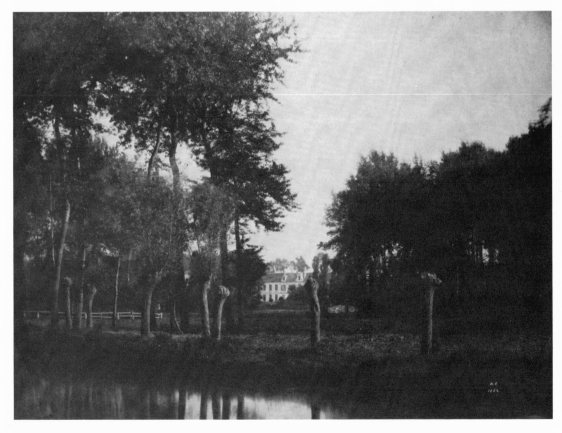

138
(ADALBERT CUVELIER)
(Landscape)
1852
Calotype
26.0 x 32.9 cm
70:0105:1
Provenance: Gabriel Cromer
 Collection

140
CHARLES MARVILLE
(Landscape)
1857
Calotype
26.0 x 35.6 cm
81:1530:4
Provenance: Gabriel Cromer
 Collection

143
E. NICOLAS
(Landscape)
ca. 1855
Modern print from paper negative
 in the collection of André
 Jammes
21.3 x 27.9 cm
80:0531:13MP
Museum purchase

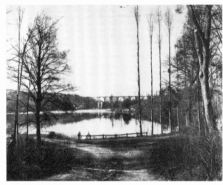

142
E. NICOLAS
(Landscape)
ca. 1855
Modern print from paper negative
 in the collection of André
 Jammes
22.2 x 28.3 cm
80:0531:14MP
Museum purchase

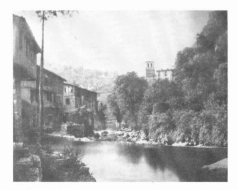

141
(ANDRE) GIROUX
(Landscape)
ca. 1855
Salted paper print
28.2 x 32.0 cm
Provenance: Wadsworth Public
 Library, Geneseo
Museum purchase

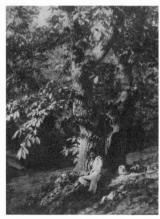

144
CHARLES MARVILLE
(Man resting under a tree), from
 Etudes photographiques,
 Louis-Désiré Blanquart-Evrard,
 editor
ca. 1853
Salted paper print
21.0 x 16.0 cm
81:1106:1
Provenance: Gabriel Cromer
 Collection

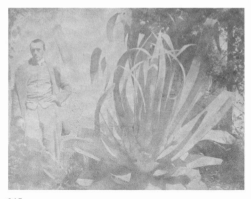

145
UNIDENTIFIED
 PHOTOGRAPHER
(Man with aloe plant)
ca. 1845-1850
Salted paper print
16.2 x 21.3 cm
82:1645:1
Provenance: Gabriel Cromer
 Collection

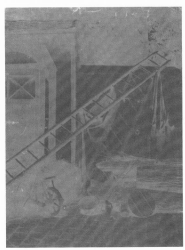

146
(LOUIS-DESIRE
 BLANQUART-EVRARD)
(Still life with farm tools)
ca. 1850-1855
Waxed paper negative
26.0 x 20.0 cm
82:0039:1

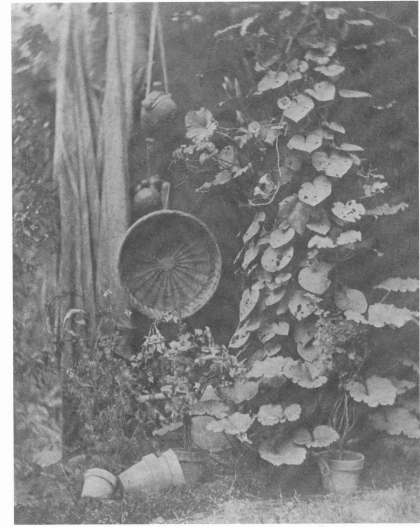

147
(LOUIS-DESIRE
 BLANQUART-EVRARD)
(Garden scene)
ca. 1850-1855
Salted paper print
14.7 x 12.1 cm
81:1105:3

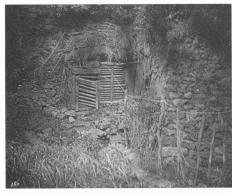

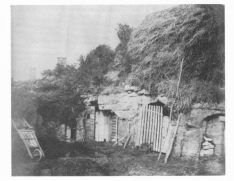

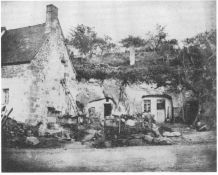

148
UNIDENTIFIED
 PHOTOGRAPHER
(LOUIS-DESIRE
 BLANQUART-EVRARD
 CAHIER 2)
(Landscape with hut)
ca. 1851-1855 (negative)
Modern print from paper negative
27.8 x 20.7 cm
81:1113:6MP
Provenance: Henri Fontan

149
UNIDENTIFIED
 PHOTOGRAPHER
(LOUIS-DESIRE
 BLANQUART-EVRARD
 CAHIER 4)
(Corner of a farm)
ca. 1851-1855
Albumen print
20.8 x 25.8 cm
81:1115:3
Provenance: Henri Fontan

150
UNIDENTIFIED
 PHOTOGRAPHER
(LOUIS-DESIRE
 BLANQUART-EVRARD
 CAHIER 4)
(Corner of a farm)
ca. 1851-1855
Salted paper print
20.3 x 26.0 cm
81:1115:4
Provenance: Henri Fontan

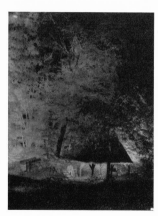

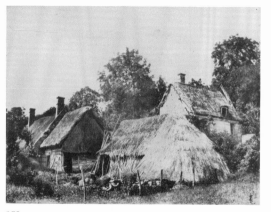

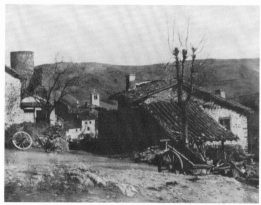

151
VICTOR PREVOST
Forêt de Compiègne
ca. 1853
Waxed paper negative
34.0 x 26.2 cm
81:2543:11

152
VICTOR PREVOST
(Corner of a farm)
ca. 1855
Calotype
24.5 x 32.6 cm
74:0021:2
Gift of William Fletcher

153
BERNABE
(House on mountain)
ca. 1850-1855
Albumen print?
18.7 x 24.7 cm
78:0652:1

154
UNIDENTIFIED
 PHOTOGRAPHER
Les Charmettes (Landscape with
 house)
ca. 1850-1855
Salted paper print
12.0 x 16.7 cm
82:1647:1

155
(?VICTOR REGNAULT)
(Buildings with trees, garden and
 garden statue)
ca. 1850-1855
Salted paper print
20.2 x 25.3 cm
82:1702:1
Provenance: Gabriel Cromer
 Collection

156
UNIDENTIFIED
 PHOTOGRAPHER
(LOUIS-DESIRE
 BLANQUART-EVRARD
 CAHIER 4)
(Fountain in front of building)
ca. 1851-1855
Salted paper print
26.4 x 20.6 cm
81:1115:8
Provenance: Henri Fontan

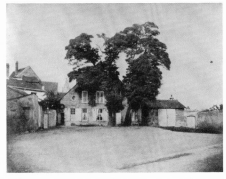

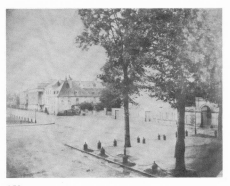

157
UNIDENTIFIED
 PHOTOGRAPHER
 (LOUIS-DESIRE
 BLANQUART-EVRARD
 CAHIER 5)
(Landscape with Hôtel du Grande
 St. Michel, Tenu par Bibard)
ca. 1851-1855
Salted paper print
19.3 x 25.8 cm
81:1116:12
Provenance: Henri Fontan

158
UNIDENTIFIED
 PHOTOGRAPHER
 (LOUIS-DESIRE
 BLANQUART-EVRARD
 CAHIER 5)
(Village scene)
ca. 1851-1855
Albumen print
19.5 x 26.2 cm
81:1116:3
Provenance: Henri Fontan

159
UNIDENTIFIED
 PHOTOGRAPHER
 (LOUIS-DESIRE
 BLANQUART-EVRARD
 CAHIER 4)
(Town square)
ca. 1851-1855
Salted paper print
19.8 x 26.2 cm
81:1115:12
Provenance: Henri Fontan

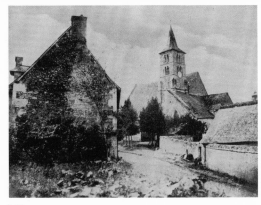

160
UNIDENTIFIED
 PHOTOGRAPHER
 (LOUIS-DESIRE
 BLANQUART-EVRARD
 CAHIER 4)
(Village scene)
ca. 1851-1855
Salted paper print
19.6 x 26.2 cm
81:1115:15
Provenance: Henri Fontan

165
LEON TRIPIER
Maison de l'auteur à St.
 Germain-en-Laye au milieu de
 la rue de Lorraine
 (anciennement caserne des
 Invalides)
ca. 1850-1855
Calotype
29.7 x 25.0 cm
82:1641:4
Provenance: Gabriel Cromer
 Collection

166
LEON TRIPIER
Chemin de fer atmosphérique de
 St. Germain en Laies (sic)
ca. 1850-1855
Calotype
30.0 x 25.0 cm
82:1641:2
Provenance: Gabriel Cromer
 Collection

161 (not illustrated)
VICTOR REGNAULT
(Landscape with tree)
ca. 1855
Modern reproduction of a
 calotype in Kodak Museum,
 Harrow
24.7 x 20.8 cm
67:0028:1CP
Gift of Eastman Kodak Ltd.,
 Harrow, England

162 (not illustrated)
VICTOR REGNAULT
(View of Sèvres)
ca. 1855
Modern facsimile of original
 calotype in Kodak Museum,
 Harrow
42.3 x 34.6 cm
81:1676:1CP
Gift of Eastman Kodak Ltd.,
 Harrow, England

163 (not illustrated)
BERNABE
(Village road)
ca. 1855
Albumen print
19.0 x 24.5 cm
70:0049:35

164 (not illustrated)
E. NICOLAS
(Street scene)
ca. 1855
Modern print from paper negative
 in the collection of André
 Jammes
22.4 x 28.6 cm
80:0531:20MP
Museum purchase

V. Transport, Industrial Advance and Leisure

The era of the 1850s and early 1860s was one of great railway documentation in France. The majority of the work by Edouard Baldus in the Eastman House comes from various albums devoted to this subject: *Chemin de Fer du Nord, Ligne de Paris à Compiègne par Chantilly*, 1853 (73), the larger format *Chemin de Fer du Nord* of later in the decade (74-75, 168-170), and *Chemin de Fer de Paris à Lyon et à la Méditerannée* (sic), ca. 1855, (76). Bisson frères' view of La Vaux (167) and Collard's later *Chemin de Fer du Bourbonnais* (171-173) present the newest engines and facilities with sophisticated artistic abstraction. All three photographers offer such impressive pictures that it is easy to forget the period's exciting new advances, made possible by the industrial revolution and a throng of inventors in the area of transport, civil engineering and communications.

After the railway mania of the first half of the century, transport by this method was firmly established. In subsequent years the French engineer Giffard introduced the first practical injector system for steam engines, Foucault was developing regulators applicable to the steam engine, and station design advanced. The application of scientific study to practical engineering allowed greater bridge feats with better security because of well calculated stress and strain and earth-pressure. This resulted from new methods of design and foundation-work, and, of course, because of new uses of iron. The huge iron and glass railroad stations—which Monet later painted—evolved during this time and made a major contribution to modern architecture. Iron construction had taken hold in shipbuilding as well.

The outlook on small boats and harbors, and especially Dieppe, was different. LeSecq (60-61), LeGray (perhaps among 33-34) and Nicolas (178-181) frequented Dieppe when Delacroix and many other artists were there. Boat scenes occur in the Durieu album too, and may have been taken at the time that Durieu and Delacroix were working together on photographic *acadèmies*. Honfleur, the home of Jongkind and the pre-Impressionists, fits into the same picture (124-125). These seaside views present the more casual genre approach of upper class leisure that was so typical of the pre-Impressionist style. Both images of industrial advance and scenes of private relaxation formed an integral part of early photographic iconography and were passed on to Realist and Impressionist painters in their turn.

167
BISSON FRERES
(1 La Vaux, locomotive)
ca. 1858
Albumen print?
31.5 x 43.6 cm
81:1009:3
Provenance: Gabriel Cromer
 Collection

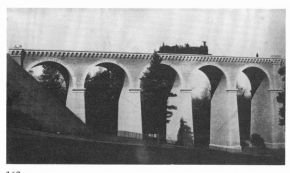

168
EDOUARD BALDUS
Paysage près du Viaduc de
 Chantilly, from the album
 *Chemin de Fer du Nord, Ligne de
 Paris à Boulogne*
ca. 1855-1860
Albumen print
23.8 x 43.0 cm
74:0051:18
Provenance: Gabriel Cromer
 Collection

169
EDOUARD BALDUS
Pont sur le Canal à St. Denis, from
 the album *Chemin de Fer du Nord,
 Ligne de Paris à Boulogne*
ca. 1855-1860
Albumen print?
22.1 x 41.2 cm
74:0051:4
Provenance: Gabriel Cromer
 Collection

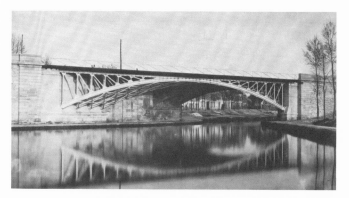

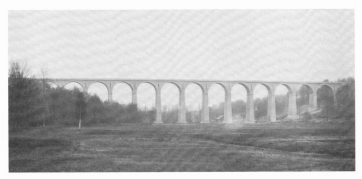

170
EDOUARD BALDUS
Ensemble du Viaduc de Comelle,
 from the album *Chemin de Fer du
 Nord, Ligne de Paris à Boulogne*
ca. 1855-1860
Albumen print
19.2 x 42.0 cm
74:0051:14
Provenance: Gabriel Cromer
 Collection

171
COLLARD
Remise Circulaire pour 32
 locomotives, à Nevers, (Premiere
 Vue Intérieure), from the album
 *Chemin de Fer du Bourbonnais,
 Moret-Nevers-Vichy*
1860-1863
Albumen print from collodion
 negative
30.7 x 22.4 cm
79:0038:28
Provenance: Gabriel Cromer
 Collection

172
COLLARD
Remise Circulaire pour 32
 locomotives à Nevers (Troisieme
 Vue Intérieure), from the album
 *Chemin de Fer du Bourbonnais,
 Moret à Nevers-Vichy*
1860-1863
Albumen print from collodion
 negative
30.9 x 22.1
79:0038:30
Provenance: Gabriel Cromer
 Collection

173
COLLARD
Viaduc de Montigny (juillet 1861),
 from *Chemin de Fer du
 Bourbonnais, Moret-Nevers-Vichy*
1861
Albumen print from collodion
 negative
18.0 x 30.5 cm
79:0038:2
Provenance: Gabriel Cromer
 Collection

174
G. SEE
Barrage de la Citanquette (7 juillet
 1863), Passe navigable vue à sec
 à l'abri des batardeaux pendant
 la pose des parties mobiles,
 from *Navigation de la Seine,
 Barrages à Hausse Mobiles*
1863
Albumen print from collodion
 negative
27.0 x 37.5 cm
73:0114:1
Provenance: Gabriel Cromer
 Collection

175
MADAME DISDERI
(Ships at Brest), from the album
 Brest et Ses Environs
ca. 1856
Albumen print from collodion
 negative
20.0 x 27.0 cm
80:0256:7
Provenance: Gabriel Cromer
 Collection

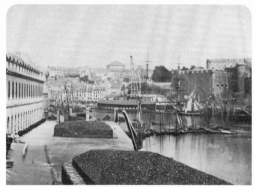

176
MADAME DISDERI
(Port of Brest), from the album
 Brest et Ses Environs
ca. 1856
Albumen print from collodion
 negative
17.1 x 24.0 cm
80:0256:22
Provenance: Gabriel Cromer
 Collection

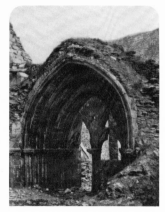

177
MADAME DISDERI
(Ruined Gothic archway, Chapel
 of the Alley of St. Matthew),
 from the album *Brest et Ses
 Environs*
ca. 1856
Albumen print from collodion
 negative
27.9 x 21.9
80:0256:8
Provenance: Gabriel Cromer
 Collection

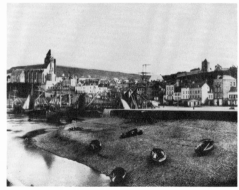

179
E. NICOLAS
(View of Dieppe)
ca. 1855
Modern print from paper negative
 in the collection of André
 Jammes
22.1 x 28.8 cm
80:0531:8MP
Museum purchase

180
E. NICOLAS
(Town on the sea, Normandy)
ca. 1855
Modern print from paper negative
 in the collection of André
 Jammes
22.1 x 28.8 cm
80:0531:17MP
Museum purchase

178 *(not illustrated)*
E. NICOLAS
(Seaside town, perhaps Dieppe)
ca. 1855
Modern print from paper negative
 in the collection of André
 Jammes
21.9 x 28.6 cm
80:0531:23MP
Museum purchase

181 *(not illustrated)*
E. NICOLAS
(Casino and bath-house at Dieppe)
ca. 1855
Modern print from paper negative
 in the collection of André
 Jammes
22.3 x 29.0 cm
80:0531:24MP
Museum purchase

182 *(not illustrated)*
E. NICOLAS
(View of Dieppe)
ca. 1855
Modern print from paper negative
 in the collection of André
 Jammes
22.4 x 29.0
80:0531:7MP
Museum purchase

183 *(not illustrated)*
E. NICOLAS
(Castle ruins)
ca. 1855
Modern print from paper negative
 in the collection of André
 Jammes
22.4 x 29.0 cm
80:0531:27MP
Museum purchase

VI. Foreign Associates and Frenchmen Abroad

Though America took the lead in daguerreotypy, France formed the center of influence in the area of paper photography. From the earliest photographic exhibits and projects we find foreign associates gathering closely around the French. Because Lille was so near to Belgium, Blanquart-Evrard paid equal attention to the photographers of Brussels and Bruges, like Desplanques (84) and de Claine (85); and Fierlants, who for a while in the 1850s operated from Paris, continued later from Brussels to sell to Parisians through Didron, *éditeur* (24, 25, 184-185). The connections between the two cities would always be close.

In Rome, French residents acted as a catalyst for the new medium. Count Flacheron (189) was the center of a French school that included Italian enthusiasts as well. The foremost among these was the Venetian painter Giacomo Caneva (187-188), who produced exquisite views of Rome and its surrounding landscape. The French contingency (which included Eugène Constant, a glass-negative photographer working as early as 1848, M. Robinson and Prince Giron des Anglonnes) evidently met evenings at the fashionable Café Greco, just below the Spanish Steps and the Villa Medici of the French Academy. An early calotypist associated with the French Academy was the architect Alfred Normand, whose work, recently recovered, includes panoramas of the type shown here (190). An entire portfolio relating to this print is housed at the Museum. The buildings are identified in English, and the owner or photographer could have been visiting from that country as well.

A combination of romanticism, scientific inquiry and French political expansionism caused photographers to extend themselves further abroad in other ways too. Maxime DuCamp (191-197) brought back a piece of the "Oriental Experience" in the over 200 calotypes that he made while travelling through Egypt with the writer Gustave Flaubert. He was but one of many compatriots who ventured to do the same (among them Teynard, Maunier, DeClercq and Vicomte de Banville). DuCamp travelled under the auspices of the Ministry of the Interior, and while he photographed several landscapes which are not well known, he took his charge to document the ancient monuments seriously. The painter Auguste Salzmann went to Jerusalem with a camera in order to document the city to prove Ferdinand de Saulcy's controversial archeological theory that many religious monuments there were built in Old Testament days—a project of a more specific nature. Both DuCamp's work and Salzmann's, however, manifest a romanticism about the "Orient", still highly *au courant* in the early 1850s and ready to be translated into photographic terms.

Several French photographers strayed even farther afield. Victor Prevost, a student of the painter Paul Delaroche (along with LeGray, LeSecq and Nègre), moved to America in 1848 (returning to France in 1852-3) and became a professional photographer with P.C. Duchochois in New York City from 1853 to 1855, and with C.D. Fredericks until 1857. He introduced the waxed paper negative and then the albumen and collodion processes to this country.

Désiré Charnay was an explorer and the first to publish photographs of the Mayan ruins in Mexico. He also took his camera to Madagascar, Java and Australia. His Mexican trip was financed by the French Ministry of Public Education, one of the many government supported documentary efforts of its kind to accept "photography as a witness" (see below under "Patronage"). Charnay's medium was the wet collodion glass negative, except for occasional emergency use of the slower paper negative when collodion or glass was unavailable.

Finally, Chodzkiewiez seems to be one of many foreigners who resided in France, but little is known about him apart from his Parisian address.

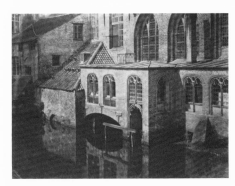

184
E. FIERLANTS
Hôpital St. Jean
ca. 1855-1860
Treated albumen print from glass
 negative?
70:0049:21

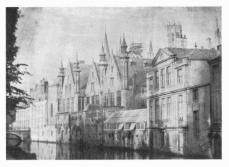

185
E. FIERLANTS
Le Franc à Bruges
ca. 1855-1860
Treated albumen print from glass
 negative?
26.7 x 38.8 cm
70:0049:27

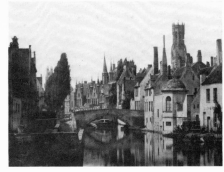

186
J.F. MICHIELS
Vue latérale du Franc de Bruges,
 prise du pont du Moulin, from
 Variétés Photographiques,
 Louis-Désiré Blanquart-Evrard,
 editor
ca. 1853-1854
Salted paper print
22.8 x 30.2 cm
81:1640:1
Provenance: Gabriel Cromer
 Collection

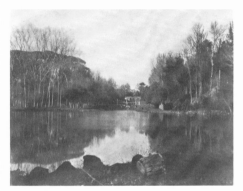

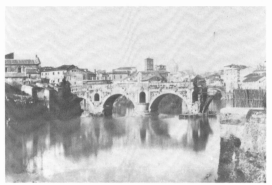

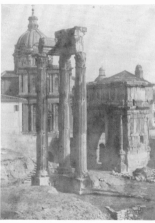

187
GIACOMO CANEVA
(Landscape)
ca. 1855
Calotype
27.3 x 20.2 cm
79:1998:3

188
GIACOMO CANEVA
(View of Rome)
ca. 1855
Calotype
17.6 x 27.3
79:1998:2

189
COUNT FLACHERON
(The Roman Forum)
1850
Calotype
33.7 x 25.0 cm
82:1622:1
Provenance: Gabriel Cromer
 Collection

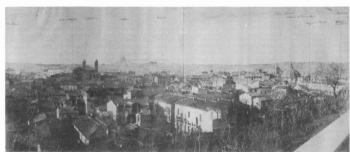

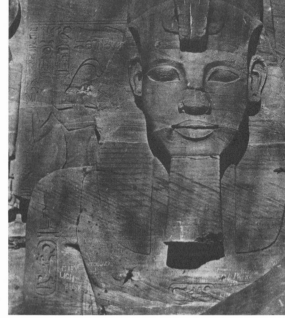

190
UNIDENTIFIED
PHOTOGRAPHER (?French)
(Panorama of Rome)
ca. 1850
Salted paper prints (2 attached
 together)
(complete) 20.9 x 51.8 cm
82:1640:1
Provenance: Alden Scott Boyer
 Collection

191
MAXIME DUCAMP
Ibsamboul, Colosse Médial du
 Spéos de Phrè, from *Egypte,
 Nubie, Palestine et Syrie*
1852 (publication)
Calotype (Blanquart-Evrard)
20.8 x 16.3 cm
76:0110:106
Provenance: Alden Scott Boyer
 Collection; A. Dutilleul

191a
MAXIME DUCAMP
Nubie, Grand Temple d'Isis, à
 Philoe, Proscynéma, from *Egypte,*
 Nubie, Palestine et Syrie
1852 (publication)
Calotype (Blanquart-Evrard)
16.1 x 22.1 cm
76:0110:78
Provenance: Alden Scott Boyer
 Collection; A. Dutilleul

193
MAXIME DUCAMP
Nubie, Ibsamboul, Entrée du
 Spéos d'Hathor, from *Egypte,*
 Nubie, Palestine et Syrie
1852 (publication)
Calotype (Blanquart-Evrard)
21.5 x 16.5 cm
79:0031:41
Provenance: Gabriel Cromer
 Collection

192
MAXIME DUCAMP
Egypte Moyenne, Le Sphinx, from
 Egypte, Nubie, Palestine et Syrie
1852 (publication)
Calotype (Blanquart-Evrard)
15.7 x 20.7 cm
79:0030:11
Provenance: Gabriel Cromer
 Collection

194
MAXIME DUCAMP
Haute Egypte, Temple d'Ombos,
 from *Egypte, Nubie, Palestine et Syrie*
1852 (publication)
Calotype (Blanquart-Evrard)
16.6 x 22.0 cm
79:0030:64
Provenance: Gabriel Cromer
 Collection

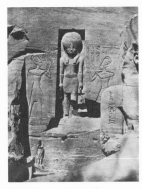

196
MAXIME DUCAMP
Nubie, Ibsamboul, Sculptures
 de l'Entrée du Spéos de
 Phrè, from *Egypte, Nubie,*
 Palestine et Syrie
1852 (publication)
Calotype (Blanquart-Evrard)
21.4 x 16.9 cm
79:0031:38
Provenance: Gabriel Cromer
 Collection

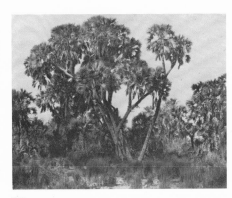

197
MAXIME DUCAMP
Haute Egypte, from *Egypte, Nubie,*
 Palestine et Syrie
1852 (publication)
Calotype (Blanquart-Evrard)
16.4 x 20.7 cm
79:0030:21
Provenance: Gabriel Cromer
 Collection

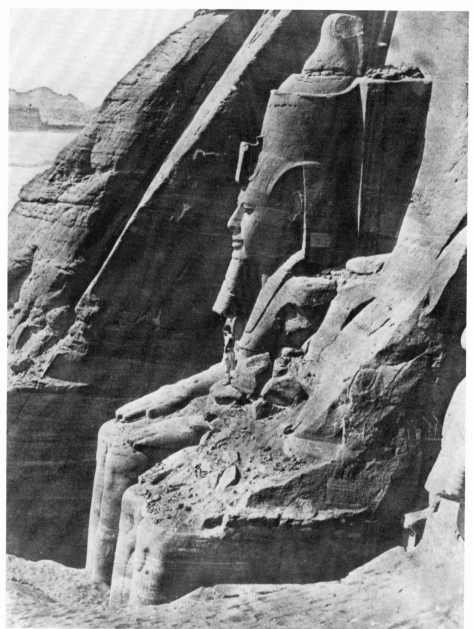

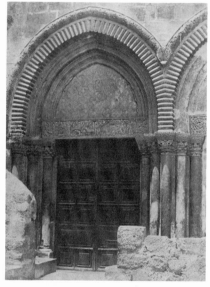

195
MAXIME DUCAMP
Nubie, Ibsamboul, Colosse
 Oriental du Spéos de Phrè, from
 Egypte, Nubie, Palestine et Syrie
1852 (publication)
Calotype (Blanquart-Evrard)
21.5 x 16.3 cm
79:0031:37
Provenance: Gabriel Cromer
 Collection

198
(MAXIME DUCAMP)
Porte d'entrée du St. Sépulchre,
 Jérusalem
1852
Calotype?
25.4 x 19.0 cm
81:1187:1
Provenance: A. E. Marshall
 Collection
Museum purchase

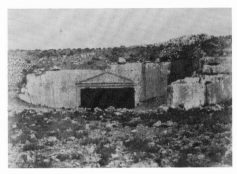

199
AUGUSTE SALZMANN
Tombeau des Juges, from *Jérusalem*
ca. 1856
Calotype (Blanquart-Evrard)
23.0 x 33.0 cm
71:0117:3

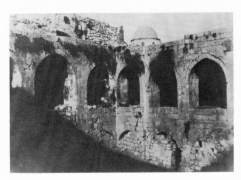

200
AUGUSTE SALZMANN
(Courtyard, detail), from *Jérusalem*
ca. 1856
Calotype (Blanquart-Evrard)
23.2 x 33.5 cm
71:0117:9

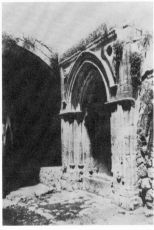

201
AUGUSTE SALZMANN
(Gothic archway) from *Jérusalem*
ca. 1856
Calotype (Blanquart-Evrard)
33.0 x 23.5 cm
71:0117:1

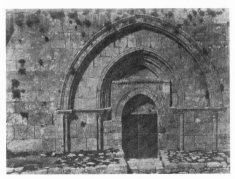

202
(AUGUSTE SALZMANN)
(Wall with Gothic portal from
 Jérusalem)
ca. 1856
Calotype (Blanquart-Evrard)
23.5 x 33.2 cm
71:0117:10

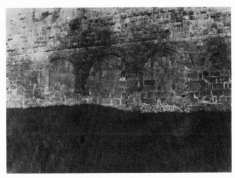

203
AUGUSTE SALZMANN
Enciente du Temple, Triple porte
 romaine, from *Jérusalem*
ca. 1856
Calotype (Blanquart-Evrard)
22.2 x 32.0 cm
79:2893:1

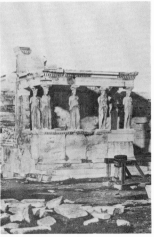

204
EUGENE PIOT
L'Acropole d'Athènes, Pandroseion
1852
Salted paper print
32.7 x 22.6 cm
82:1564:1
Museum purchase, Lila Acheson
 Wallace Purchase Fund

205
P. MARES
Vue de la partie nord du Ksar
 d'Arba Tatani, from the album
 Souvenir de Voyage dans le Sud de
 l'Algérie
ca. 1850
Albumen print?
16.4 x 25.6 cm
73:0232:6
Provenance: Gabriel Cromer
 Collection

205a
P. MARES
Salle-à-manger des officiers à la
 redoute d'Ain Ben Khelil, from
 the album *Souvenir de Voyage dans*
 le Sud de l'Algérie
ca. 1850
Albumen print?
17.7 x 25.3 cm
73:0232:2
Provenance: Gabriel Cromer
 Collection

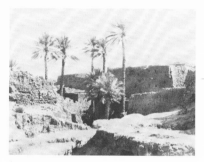

205b
P. MARES
Partie Nord du Ksar de Lyout,
 from the album *Souvenir de*
 Voyage dans le Sud de l'Algérie
ca. 1850
Albumen print?
19.0 x 24.8 cm
73:0232:3
Provenance: Gabriel Cromer
 Collection

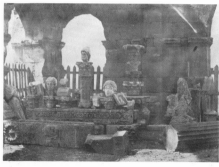

206
UNIDENTIFIED
 PHOTOGRAPHER
 (?LA PARANOLA)
Musée de Lambessa (Ruinés
 Romaines), from *Album*
 photographique de Vues-Types
 Algériens et Ruins Romaines
ca. 1860
Albumen print from glass
 negative?
16.9 x 23.5 cm
73:0231:3
Provenance: Gabriel Cromer
 Collection

207
UNIDENTIFIED
 PHOTOGRAPHER
 (?LA PARANOLA)
Type de femme Mauresque (de la
 tribu des Oued-Nayle, Msila),
 from *Album photographique de*
 Vues-Types Algériens et Ruins
 Romaines
ca. 1860
Albumen print from glass
 negative?
16.8 x 22.2 cm
73:0231:10
Provenance: Gabriel Cromer
 Collection

208
UNIDENTIFIED
 PHOTOGRAPHER
 (?LA PARANOLA)
Type de femme Mauresque
 (Constantine), from *Album*
 photographique de Vues-Types
 Algériens et Ruins Romaines
ca. 1860
Albumen print from glass
 negative?
14.3 x 19.5 cm
73:0231:20
Provenance: Gabriel Cromer
 Collection

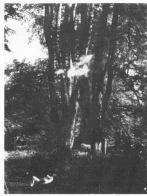

209
VICTOR PREVOST
Forêt de Compiègne (man,
 perhaps Prevost, resting
 under trees)
1853
Modern print from paper
 negative
33.6 x 25.7 cm
81:2543:37MP

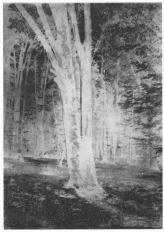

210
VICTOR PREVOST
Forêt de Compiègne (?Le voisin
 fondu)
1853
Waxed paper negative, retouched
34.1 x 26.1 cm
81:2543:49

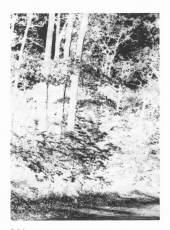

211
VICTOR PREVOST
Route de St. Pierre, Compiègne
1852
Waxed paper negative, retouched
33.7 x 26.0 cm
81:2543:43

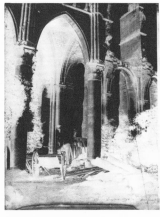

212
VICTOR PREVOST
Long Pont
1853
Waxed paper negative
33.5 x 26.0 cm
81:2543:34

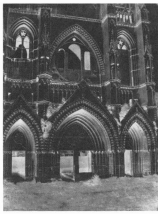

213
VICTOR PREVOST
St. Jean des Vignes à Soisson
1853
Modern print from paper negative
33.8 x 25.8 cm
81:2543:27MP

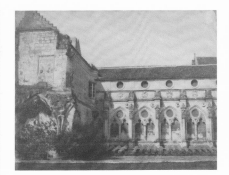

214
VICTOR PREVOST
Cloître St. Jean des Vignes
1853
Calotype
25.2 x 32.3 cm
74:0021:1
Gift of William Fletcher

215
VICTOR PREVOST
(Landscape with wall)
ca. 1855
Modern print from paper negative
24.6 x 33.7 cm
81:2543:7MP

216
VICTOR PREVOST
(Farm and landscape)
ca. 1855
Waxed paper negative
25.0 x 31.2 cm
81:2543:24

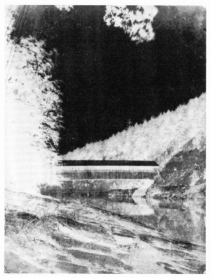

218
VICTOR PREVOST
(Landscape with covered bridge)
ca. 1855
Waxed paper negative
(negative) 34.3 x 26.0 cm
81:2543:44

217 *(not illustrated)*
VICTOR PREVOST
(Landscape with covered bridge)
ca. 1855
Waxed paper negative
(negative) 26.1 x 34.4 cm
81:2543:31

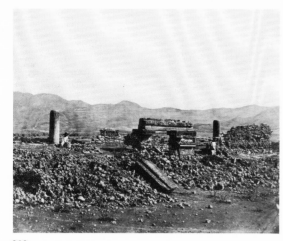

219
DESIRE CHARNAY
Mitla Mexico, from an album of
 Aztec monuments in Mexico
ca. 1857
Albumen print from collodion
 negative
33.9 x 42.8 cm
73:0199:5
Provenance: Gabriel Cromer
 Collection

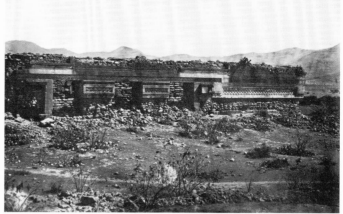

220
DESIRE CHARNAY
Mitla Mexico, Palace II façade,
 from an album of Aztec
 monuments in Mexico
ca. 1857
Albumen print from collodion
 negative
27.8 x 40.5 cm
73:0199:22
Provenance: Gabriel Cromer
 Collection

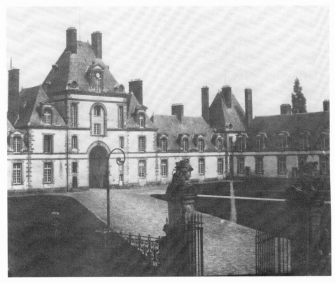

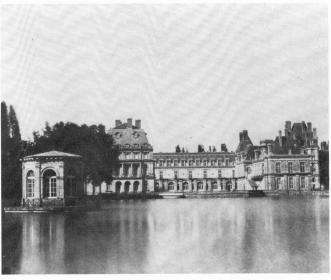

221
CHODZKIEWIEZ
Fontainebleau, La Cour de Chasse
ca. 1850-1855
Calotype
19.8 x 24.5
81:2935:1
Provenance: Gabriel Cromer
 Collection

223
CHODZKIEWIEZ
Fontainbleau, Le Pavillon
 Napoléon
ca. 1850-1855
Calotype
19.8 x 25.0 cm
81:2934:6
Provenance: Gabriel Cromer
 Collection

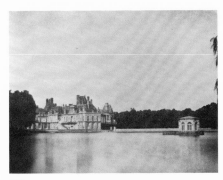

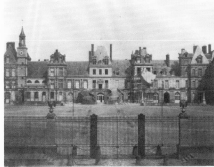

222
CHODZKIEWIEZ
La Pièce d'Eau du Château
ca. 1850-1855
Calotype
19.2 x 24.5 cm
81:2934:9
Provenance: Gabriel Cromer
 Collection

224
CHODZKIEWIEZ
Fontainebleau, La Grande Fontaine
 et le Parc
ca. 1850-1855
Calotype
19.8 x 24.8 cm
81:2934:8
Provenance: Gabriel Cromer
 Collection

225
CHODZKIEWIEZ
Fontainebleau, La Façade
 principale
ca. 1850-1855
Calotype
19.5 x 24.8 cm
81:2934:7
Provenance: Gabriel Cromer
 Collection

VII. The Future: Glass-Negative Masters

At least half the photographers represented here worked at some time with glass-negative photography. Braun, Bilordeaux and Boitouzet are among those who probably never worked extensively in calotypy. All three photographers were professionals. From the earliest days of their invention, glass negatives were considered appropriate for studio photography (too fragile for voyages). Still lifes emerged as one of the earliest subject matter concentrations. Looking back to the commercial registries of the 1840s and to Gaudin's remarks in 1851 (see above), we know that the daguerreotype's sharpness and fine tonal range, rather than the calotype's artistic *brouillards*, was the choice of the masses. From the success of commercial photographers who used the detail-prone glass negatives in the 1850s, we can surmise that the public and the times demanded this accuracy and that only a few artists and *amateurs* continued to use the paper negative in the early 1860s. Hardly anyone was still exhibiting them, let alone employing them for commercial purposes. Of the 296 photographers who advertised in the Paris commercial registry of 1862, only a handful are known to have worked extensively in the calotype medium. Baldus and Bayard are among these few, but both had long since added to their repertoire or completely switched to the popular glass-negative medium. A period of experimentation and intense interchange with the art world had subsided, the playful adolescence of photography had passed and future masterpieces were to appear based more on the aesthetic of the glass-negative photographer than the aesthetic of the artist-amateur, the calotypist.

226
TOURNACHON JNE.
Poule, Née en 1853, Son père,
 Bayard, sa mère, Cocotte, 1r.
 Pris des Juments, Race
 Percheronne de gros trait, from
 *Races Chevaline et Asine, Primés à
 l'Exposition de 1855*
ca. 1855-1860
Albumen print?
17.7 x 23.8 cm
79:0002:18
Provenance: Gabriel Cromer
 Collection

227
TOURNACHON JNE.
Ratter-Filly, née en 1851. Son père,
 Bolero, pur sang Anglaise, sa
 mère, Camargo, par Y. Rattler,
 demi-sang, 1r. Prix des Juments,
 Race Normande, de demi-sang
 léger, from *Races Chevaline et
 Asine, Primés à l'Exposition de
 1855*
ca. 1855-1860
Albumen print?
16.8 x 23.0 cm
79:0002:25
Provenance: Gabriel Cromer
 Collection

228
TOURNACHON JNE.
Selim, Né en 1849, Son père, Calif,
 pur sang Anglo-Arabe, sa mère
 par Alfred, demi-sang. 3e. Prix
 des Etalons, Races diverses de
 demi-sang léger, from *Races
 Chevaline et Asine, Primés à
 l'Exposition de 1855*
ca. 1855-1860
Albumen print?
17.0 x 22.6 cm
79:0002:26
Provenance: Gabriel Cromer
 Collection

229
TOURNACHON JNE.
Sébastopol, Né en 1852. Son père,
 un étalon de pur sang Arabe, sa
 mère, un Jument croisée
 Anglaise, 1r. Prix des Etalon,
 Races diverses de demi-sang
 léger, from *Races Chevaline et
 Asine, Primés à l'Exposition de
 1855*
ca. 1855-1860
Salted paper print?
17.3 x 22.5 cm
79:0002:33
Provenance: Gabriel Cromer
 Collection

230
TOURNACHON JNE.
Trotteur, Né en 1855, Son père et
 sa mère de Race Boulonnaise 1r.
 Prix des Etalons, Race
 Boulonnaise de gros trait, from
 Races Chevaline et Asine, Primés à
 l'Exposition de 1855
ca. 1855-1860
Salted paper print?
17.0 x 24.1 cm
79:0002:3
Provenance: Gabriel Cromer
 Collection

231
TOURNACHON JNE.
Sorcière, Née en 1850, Son père
 Gil Blas, demi-sang, Sa mère
 une Jument Boulonnaise, 1r. Prix
 des Juments, Races diverses de
 demi-sang Carosier, from *Races*
 Chevaline et Asine, Primés à
 l'Exposition de 1855
ca. 1855-1860
Salted paper print?
17.8 x 24.0 cm
79:0002:35
Provenance: Gabriel Cromer
 Collection

232
ADOLPHE BRAUN
(Flowers)
ca. 1856
Albumen print from glass negative
48.8 x 41.0 cm
81:2070:6
Provenance: Gabriel Cromer
 Collection

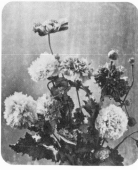

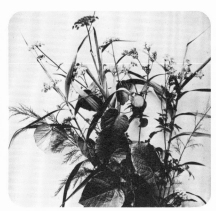

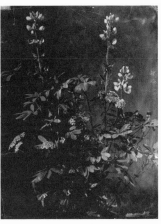

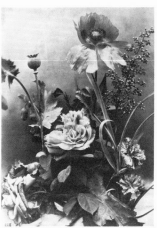

239
ADOLPHE BRAUN
(Poppies)
ca. 1856
Albumen print from glass
negative
44.3 x 38.0 cm
81:1005:1
Provenance: Gabriel Cromer
 Collection

233
ADOLPHE BRAUN
(Flowers)
1856
Albumen print from glass negative
43.8 x 46.5 cm
77:0033:13
Provenance: Gabriel Cromer
 Collection

234
ADOLPHE BRAUN
(Flowers)
ca. 1857
Albumen print from glass negative
30.5 x 24.6 cm
69:0104:1

235
ADOLPHE BRAUN
Roses, parots et oeilles
ca. 1857
Albumen print from glass negative
34.7 x 25.2 cm
81:2071:1

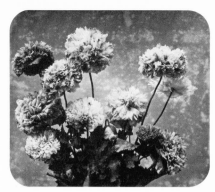

236
ADOLPHE BRAUN
(Double poppies)
ca. 1856
Albumen print from glass negative
38.7 x 45.0 cm
81:1005:3
Provenance: Gabriel Cromer
 Collection

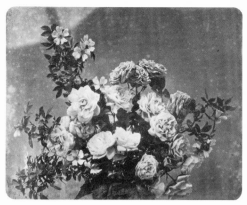

237
ADOLPHE BRAUN
(Roses)
ca. 1856
Albumen print from glass negative
37.7 x 47.7 cm
81:1005:2
Provenance: Gabriel Cromer
 Collection

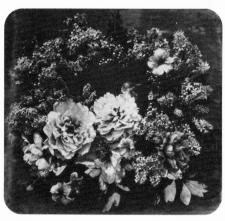

238
ADOLPHE BRAUN
(Camelias and lilacs)
ca. 1856
Albumen print from glass negative
44.7 x 48.7 cm
81:1005:4
Provenance: Gabriel Cromer
 Collection

240
J. BOITOUZET
(Still life with bouquet of flowers
 and statuette)
ca. 1855
Salted paper print from glass
 negative
19.1 x 16.2 cm
81:0995:2

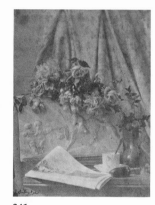

241
J. BOITOUZET
(Still life)
ca. 1855
Salted paper print from glass
 negative
20.0 x 15.8 cm
81:0995:1

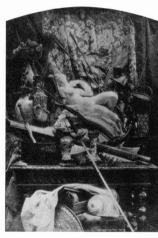

242
ADOLPHE BILORDEAUX
(Still life)
ca. 1859
Albumen print from glass negative
42.2 x 30.1 cm
81:0976:2
Provenance: Gabriel Cromer
 Collection

243
ADOLPHE BILORDEAUX
(Still life)
ca. 1859
Albumen print from glass negative
39.9 x 30.2 cm
81:0976:1
Provenance: Gabriel Cromer
 Collection

VIII. Patronage: Government Commissions and the Imperial Library at Compiègne

The invention of photography emerged during the reign of King Louis-Philippe. Some government subvention—beyond the 10,000 franc pension that went to Daguerre and his partner Niépce—occurred in the early years of the medium, but it was under Emperor Napoleon III (7-10) that massive official interest arose.

The earliest major photographic commissions were from official government organs, including the *Galerie des représentants à l'assemblée constituants* (1848-50), daguerreotyped by Bisson; the Commission des Monuments Historiques' famous *missions héliographiques* of 1851 (discussed above); and the Ministry of Interior's numerous projects, including the reproduction of the principal monuments of Paris (1852), and the documentation of the flooding of the Rhône valley (1855) and of the New Louvre (1857-58), (65-68), all accomplished by Baldus. Pierre Petit had several Imperial commissions—to photograph nineteenth century personalities (by 1866); to gather an *Album des Maires et de la Commission Municipale de Paris* (1863); and to document the Universal Exposition in 1867. These set the pace for other private ventures.

In 1854, the French Society of Photography was formed, by a relatively high social class, and with a limited membership. Many of the founders were related to various government ministries—so much so that this was a hallmark of the membership. These connections naturally facilitated others. Indeed, Victor Regnault (161-162), president of the Society and of the Porcelain Manufactury of Sèvres, established one of a growing number of photographic departments within state organizations, in this case at the Manufactury.

Several ministries hired professional photographers from the outside in lieu of establishing whole departments. The Director of the Expositions Officielles des Beaux-Arts asked LeGray to photograph the Salon of 1852 (see also 20-22, probably from a similar request) and Adrien Tournachon recorded the horses and other animals at the Universal Exposition of 1860 for the Ministry of the Interior (see also 226-231).

Many a photographer used the seal "Photographer to the Emperor". Among these were Bisson frères (248-251) and Gustave LeGray (33). Blindstamps on other pieces in the collection remind us that Sée operated for the Ecole Impériale Polytechnique (174) and Maxime DuCamp went to Egypt under the auspices of the Ministry of Interior (191-197). Certainly one of the important encouragements to early photography, then, came from official quarters.

Private enterprise was still very much alive, of course. Baron James de Rothchild commissioned Baldus to document his railroad line (74-75, 168-170). And the Duke de Luynes offered a cash award in 1856 for the best photomechanical process.

The few prints in this section include a tiny part of the library of the Empress Eugénie and the Emperor Napoleon III at Compiègne. Bisson frères, starting in daguerreotypy and calotypy (244), moved to glass negatives later in the

1850s (245-246). By the early 1860s they had developed the rich style for which they are famous and in which they executed the commissioned documentation of the Imperial family's excursion to Mont Blanc (248-251).

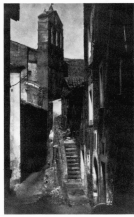

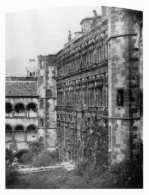

244
BISSON FRERES
(Streetview, ?Bequin)
1854
Albumen print from waxed
paper negative?
32.6 x 21.2 cm
79:1927:2
Provenance: A. E. Marshall
Collection
Museum purchase

245
BISSON FRERES
(Heidelberg, ?Bâtiment Otton
Henri)
ca. 1855
Salted paper print from glass
negative?
43.5 x 34.0 cm
81:1011:1

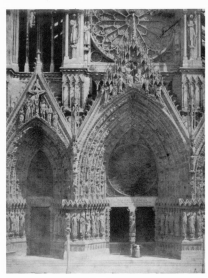

246
BISSON FRERES
(Reims Cathedral, main portal)
ca. 1855-1860
Albumen print from glass
negative?
44.7 x 36.2 cm
78:0645:4

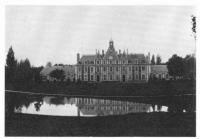

247
BISSON FRERES
Vue Génerale du Château
 d'Hermières, from an album
 presented by Ed. Renaud,
 Architect to F. Baciocchi,
 "Premier Chambellan de S. M.
 L'Empereur"
ca. 1858
Albumen print from collodion
 negative
30.6 x 45.7 cm
77:0405:11
Museum purchase

248
BISSON FRERES
Séracs, rencontre des Bossons et
 du Laconnay?, from the album
 *Haute-Savoie, Le Mont Blanc et Ses
 Glaciers, Souvenir du Voyage de LL.
 M.M. L'Empereur et L'Impératrice*
ca. 1860
Albumen print from collodion
 negative
23.3 x 38.4 cm
81:1014:17
Provenance: Gabriel Cromer
 Collection; Napoleon III

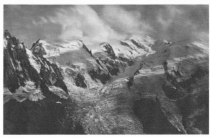

249
BISSON FRERES
Bourrasque au Mont Blanc, from
 the album *Haute-Savoie, Le Mont
 Blanc et Ses Glaciers, Souvenir du
 Voyage de LL. M.M. L'Empereur et
 L'Impératrice*
1860
Albumen print from collodion
 negative
23.0 x 38.9 cm
81:1014:6
Provenance: Gabriel Cromer
 Collection; Napoleon III

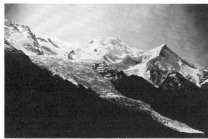

250
BISSON FRERES
Glacier des Bossons, from the
 album *Haute-Savoie, Le Mont
 Blanc et Ses Glaciers, Souvenir du
 Voyage de LL. M.M. L'Empereur et
 L'Impératrice*
1860
Albumen print from collodion
 negative
44.3 x 27.6 cm
81:1014:3
Provenance: Gabriel Cromer
 Collection; Napoleon III

251
BISSON FRERES
Seracs du Géant, from the album
 *Haute-Savoie, Le Mont Blanc et Ses
 Glaciers, Souvenir du Voyage de LL.
 M.M. L'Empereur et L'Impératrice*
1860
Albumen print from collodion
 negative
23.8 x 40.0 cm
81:1014:20
Provenance: Gabriel Cromer
 Collection; Napoleon III

252
E.D. (?E. DESMAISONS)
Cagliari, Porte Christine
ca. 1850
Calotype
19.0 x 24.2 cm
70:0049:16
Provenance: Gabriel Cromer
 Collection; Napoleon III

IX. Epilogue

These remaining few pictures are among the vast assortment of images in the collection that are unidentified at the present time. They may have been photographed by persons whose names we know, or may even be by photographers whose names we will never find in the literature. They represent the loose strings in this and many other museums that have yet to reveal their story.

253
UNIDENTIFIED
 PHOTOGRAPHER
(Garden sculpture, three putti with
 basket of fruit)
ca. 1850-1855
Salted paper print
21.8 x 16.3 cm
82:1643:1

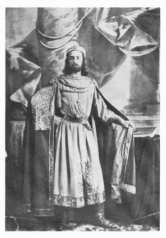

256
UNIDENTIFIED
 PHOTOGRAPHER, (?French)
(Actor in costume with crown)
ca. 1855
Salted paper print
24.0 x 17.0 cm
81:1623:1
Provenance: 3M/Sipley Collection;
 former American Museum of
 Photography

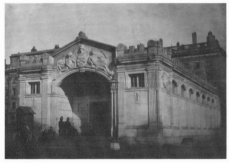

254
UNIDENTIFIED
 PHOTOGRAPHER
Corps de Garde de la Place Bellum
 à Lyon
ca. 1855
Salted paper print
22.9 x 33.1 cm
82:1641:1

255
UNIDENTIFIED
 PHOTOGRAPHER, (?French)
(Convent of Mt. Sinai)
ca. 1850
Calotype
18.6 x 32.2 cm
76:0020:64
Provenance: Wadsworth Public
 Library, Geneseo
Museum purchase

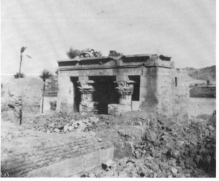

257
UNIDENTIFIED
 PHOTOGRAPHER
 (? TEYNARD), blindstamped
 Goupil
Mammisi (Philae)
ca. 1855
Albumen print
25.1 x 30.9 cm
82:1631:1

Footnotes

1. *Photographic Manipulation, The Waxed Paper Process*, 3rd ed., London, 1855 (written 1854), iii.
2. *Traité pratique de Photographie sur papier et sur verre*, Paris, 1850, l.
3. "Des progrès de la photographie", *Revue photographique*, 1858, 94.
4. "*Egypte, Nubie, Palestine et Syrie:* Dessins photographique par Maxime Du Camp", *La Lumière*, 1852, 98.
5. Francis Steegmuller, *Flaubert in Egypt: A Sensibility on Tour*, Boston, ca. 1972, 101.
6. *L'Artiste*, 1839.
7. "Revue photographique", *La Lumière*, 1852, 50.
8. *Méthodes photographiques perfectionnées, papier sec, albumine, collodion sec, collodion humide par M. M. A. Civiale, de Brébisson, Baillieu d'Avrincourt, etc . . . Notes diverses par Arthur Chevalier*, Paris, 1859.

Selected Bibliography

Alfred Stieglitz Center of the Philadelphia Museum of Art. *French Primitive Photography*, with an introduction by Minor White and commentaries by André Jammes and Robert Sobieszek. N.Y. (an Aperture Book). 1969.

Coke, Van Deren. *The Painter and the Photograph*. Albuquerque, New Mexico. 1972.

Gernsheim, Helmut and Alison. *The History of Photography*. N.Y. 1969.

Glassman, Elizabeth and Marilyn F. Symmes. *Cliché-verre: Hand-Drawn, Light-Printed*. Detroit (The Detroit Institute of Arts). 1980.

Jammes, André. *Hippolyte Bayard, Ein Verkannter Erfinder und Meister der Photographie*. Lucern. 1975.

Heilbrun, Françoise. "Un album de 'primitifs' de la photographie française". *Revue du Louvre et des Musées de France*. 1980. 21-37.

Jammes, Isabelle. *Blanquart-Evrard et les Origines de l'Edition photographique française, catalogue raisonné des albums photographiques édités, 1851-1855*. Geneva. 1981.

Janis, Eugenia. "Photography", in *The Second Empire: Art in France under Napoleon III*. Philadelphia (Philadelphia Museum of Art). 1978. 401-33.

Janis, Eugenia. "To Still the Telling Lens: Observations on the Art of French Calotype". *The Creative Eye: Essays in Photographic Criticism, Occasional Papers of the Connecticut Humanities Council (The Connecticut Scholar)*. Middletown, Connecticut. 1981. 53-64.

Marbot, Bernard. *A l'origine de la photographie: Le Calotype au passé et au présent*. Paris (Galerie de Photographie, Square Louvre). 1979.

Marbot, Bernard. *Une invention du XIXe Siècle, Expression et Technique: La Photographie, Collections de la Société Française de Photographie*. Paris (Bibliothèque Nationale). 1976.

Marbot, Bernard. *After Daguerre, Masterworks of French Photography (1848-1900) from the Bibliothèque Nationale*, with an introduction by Weston Naef. N.Y. (The Metropolitan Museum of Art). 1981.

Neagu, Philippe, André Jammes and Dr. Alfred Cayla. *Alfred-Nicolas Normand, architecte: Photographies de 1851-1852*. Paris. n.d.

Neagu, Philippe and others. *La Mission héliographique, photographies de 1851*. Paris. 1980.

Newhall, Beaumont. *The History of Photography*. N.Y. (Museum of Modern Art). 1964.

Scandlin, W. I. *Victor Prevost, Photographer, Artist, Chemist: A New Chapter in the Early History of Photography in this Country*, reprinted from *Anthony's Photographic Bulletin*. N.Y. 1901.

Scharf, Aaron. *Art and Photography*. Harmondsworth, England. 1968.

Steinert, Dr. Otto. *Die Kalotypie in Frankreich*. Essen (Museum Folkwang). 1966.

Acknowledgements

This checklist came from a much larger catalogue, typed onto computer by Jennifer Loynd Cowherd; the list was kindly refined and reordered for the exhibition by Deborah Barsel and Alan Brown. Kathy Osterhoudt typed parts of the text for word processing, and the reproductions were done by Linda McCausland, Barbara Puorro Galasso and Jeffrey Love. Ann McCabe, Registrar, has constantly helped in finding provenances through the old Museum records. Andrew Eskind, Director of Curatorial Services, coordinated these efforts.

The publication was ushered through editorial and printing stages by Christine Hawrylak. And, as usual, my words make more sense after George Pratt rearranges them. Adam Weinberg and Joanne Lukitsh aided in initial and final stages. Exhibition preparation was due to Rick Hock and Carolyn Zaft, and to Grant Romer, in charge of conservation. A debt is due to conservator Alice Swan who did special work on several of the prints. Conservation, research, cataloguing and exhibition were made possible by grants from the National Endowment for the Arts and the New York State Council on the Arts. Additional support for the catalogue has been provided by the Gannett Foundation.

Though this catalogue is only part of a larger effort in progress, it results nevertheless from seven years of access to the vast Eastman House archives, entailing the kindest of assistance from the library and print archives staff (past and present): Martha Jenks, Gretchen Van Ness, Susan Stromei, Susan Wyngaard, Gail McClain, Marta Podhorecki, Judy Bloch, Norma Feld, Mary Widger, and Rachel Stuhlman. The more intense efforts connected with cataloguing and choosing prints for exhibition were aided by Joan Pedzich, Chief Archivist, and David Wooters, Archive Assistant. In good part, it is these two who made this catalog possible before "1984". This list of helpers is long because many years have passed since my first investigations and, in a museum like this, many an excavation is necessary to reveal the full repertoire of its treasures.

Finally, Robert Doherty was director of the House when this project began, and without his enthusiastic support it could never have been done. Robert Mayer, present Director, gracefully accommodated it in his turn.

Index To Photographers

Table of Contents